BRANCUSI TO BEUYS WORKS FRC

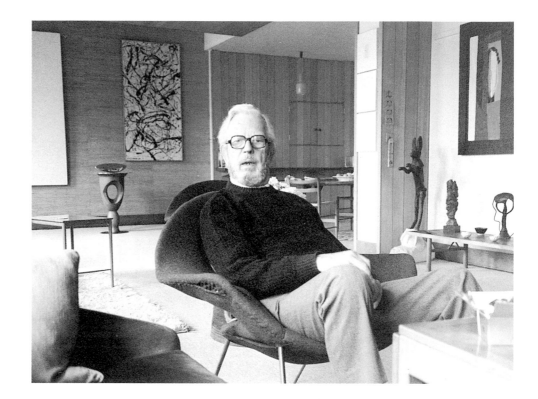

BRANCUSI TO BEUYS

author

✓ TATE GALLERY

WORKS FROM THE TED POWER COLLECTION

Edited by Jennifer Mundy

Tate Gallery Publishing

Front cover
Howard Hodgkin, *Mr and Mrs E. J. P.*, 1969–73 (detail)
(reproduced in full on p.57)

Frontispiece
E. J. Power in his flat at 37 Grosvenor Square, London,
c.1979. Behind him can be seen part of *White Fire III*, 1964,
by Barnett Newman, *Fish*, 1963 (p.24), by Brancusi, and
Untitled, 1948, by Jackson Pollock. On the side wall can be
seen part of *Interior 9AG*, 1972, by Howard Hodgkin
(fig.14), as well as a standing hare by Barry Flanagan.
Photo: Ian McIntyre

ISBN 1 85437 213 0
A catalogue record for this publication is available from the
British Library

Published in 1996 by order of the Trustees
to commemorate the exhibition at the Tate Gallery
19 November 1996 – 16 February 1997
© Tate Gallery 1996 All rights reserved
Designed and typeset by Jeremy Greenwood
Published by Tate Gallery Publishing Ltd, Millbank, London
SW1P 4RG
Printed in Great Britain by M&TJ, London

Illustrated works are copyright as follows:
Beuys, Pollock, Warhol © The estate of the artist 1996 All
rights reserved DACS
Blake, Caulfield, Dugger, Hamilton, Turnbull © The artist
1996 All rights reserved DACS
Brancusi, de Staël, Dubuffet, Picabia © ADAGP, Paris and
DACS, London 1996
Lichtenstein © The artist 1996

Photographic Credits
Hessisches Landesmuseum, Darmstadt; Marlborough Fine
Art (London) Ltd; Philadelphia Museum of Art; Tate Gallery
Photographic Department; William Turnbull; Waddington
Galleries; Graydon Wood

CONTENTS

Catalogue Note

Works shown in the exhibition are indicated by an asterisk in the Index of Catalogued Works on p.64.

The catalogue entries on pp.24–63 have been written by curatorial staff in the Modern Collection at the Tate Gallery.

Authorship of the entries is indicated in the following way:

CK Catherine Kinley

JL Jeremy Lewison

JM Jennifer Mundy

MP Michela Parkin

PM Paul Moorhouse

RM Richard Morphet

SR Sean Rainbird

Research assistance was provided by Mary Horlock.

Measurements are in centimetres followed by inches and are given in the order: height, width, depth (where appropriate). Maximum sizes are given for irregular shapes.

FOREWORD

FEW TODAY outside the circle of his former friends and acquaintances have heard of Ted Power or of his exceptional collection. Uninterested in personal publicity, he never became in any sense a public figure. Yet during the 1950s and 1960s, the main period of his collecting, he was quite simply Britain's foremost collector of contemporary art.

It is highly appropriate that this exhibition, consisting of works at one time owned by Ted Power and now part of our permanent collection, should be held here at the Tate Gallery. A Trustee from 1968 to 1975, Power was one of the Gallery's most generous and consistent supporters. He donated many paintings by both foreign and British artists, aiming always to strengthen the Tate's representation of new art. In 1980 the Gallery acquired from him a group of works, including Barnett Newman's *Eve* and Dubuffet's *Monsieur Plume with Creases in his Trousers*, which are among the highlights of the Gallery's post-war collection. Ted Power died in 1993, and earlier this year six works from his estate, including Brancusi's masterpiece *Fish* and two outstanding early Dubuffets, were allocated to the Gallery by the Department of National Heritage in lieu of tax. For this we are profoundly grateful to Ted Power's family – Derek and Alan Power, and Janet McIntyre – and those involved in the allocation at the Department of National Heritage, the Capital Taxes Office and the Museums and Galleries Commission.

Through his collecting and his friendships with artists, Power played an important if unpublicised, role in the British art scene for many years. In his text for this catalogue Leslie Waddington, a longstanding friend of Power, gives a personal appreciation of the man, and points to the many ways in which Power's qualities influenced the lives and tastes of those around him. Jennifer Mundy, Assistant Keeper in the Modern Collection, has drawn on records of Power's purchases, and on recollections of those who knew him well, to provide the first general account of Power's career as a collector, focusing in particular on the early and pioneering phase of his activities. Entries on the works that were once owned by Ted Power and are now in the Tate's collection have been written by members of the Modern Collection. It is hoped that, taken together, these texts will shed light on a remarkable collection and on the career of one of the most important British collectors of contemporary art in the twentieth century.

Nicholas Serota
Director

MEMORIES

Leslie Waddington

TED POWER AND I became friends during the last twenty years of his life. At first, before his wife Rene's death in 1978, I would go up to the flat in Grosvenor Square and we would sit drinking whisky, discussing and arguing for hours, surrounded by paintings and sculpture by people such as Dubuffet, Pollock, Turnbull, Newman, Hodgkin, Giacometti, de Staël and perhaps some new artists I would not know, whose work he wanted to test. Occasionally he would have some of the paintings replaced, because he liked change.

In the last ten years of his life, whenever we were in England, he would come to the house for lunch nearly every Sunday, sometimes alone but mostly with mutual friends. We would start talking and before we knew it, it was early evening and somehow or other he would have again opened our minds with his innate perception, never exaggerated, always exact.

Ted started his working life in the navy during the First World War as a 'Marconi', to use the crew's nickname for the radio operator. Even in his late eighties, he would take his television to bits to improve the sound quality. His approach was always empirical, he had to find out for himself, whether it was with art, farming, horses, radar, wine; he would observe, taste or test, discuss and come to a decision – although all decisions were subject to constant questioning and revision. I suppose his most attractive quality, apart from his human warmth, experience and generosity, was this open intelligence. Early in our friendship I dismissed some school of art and he quietly said to me that I should not let that limit my interest in art, that I should pick the best from each school or area: this was wonderful advice, if only I had been as perceptive as he. It summed up his collecting, of course. He had an amazingly developed eye, based on looking, his natural intelligence and never closing his mind to anything new.

His twentieth-century collection, apart from a few photographs by Laszlo Moholy-Nagy that he bought in the 1930s, started in 1951 with a Jack Yeats painting that he bought from my father in Dublin on his way back from a golfing holiday in County Cork (this purchase was quickly followed by the acquisition of another Yeats and a painting by Daniel O'Neill). He was to move swiftly in his collecting through people like Sickert, Soulages, Matthew Smith, de Staël, until by the late 1950s and early 1960s he was collecting in depth artists like Jorn, Picabia, Dubuffet, Newman, Rothko and Warhol. During this period, except for the Institute of Contemporary Arts in Dover Street, where Lawrence Alloway organised the exhibitions, and the Whitechapel Art Gallery, directed by Bryan Robertson, the only place in London where you could continually see great international contemporary art was in Ted and Rene's flat. The ICA was a meeting place for artists and people who were involved in modern art , and yet it was in their flat in Grosvenor Square that many of the most serious discussions took place with individual artists, some of whose names I mention here.

Ted always liked the presence of artists and regarded them as special and an important part of the world: they were 'antennae', pinpointing areas long before we knew

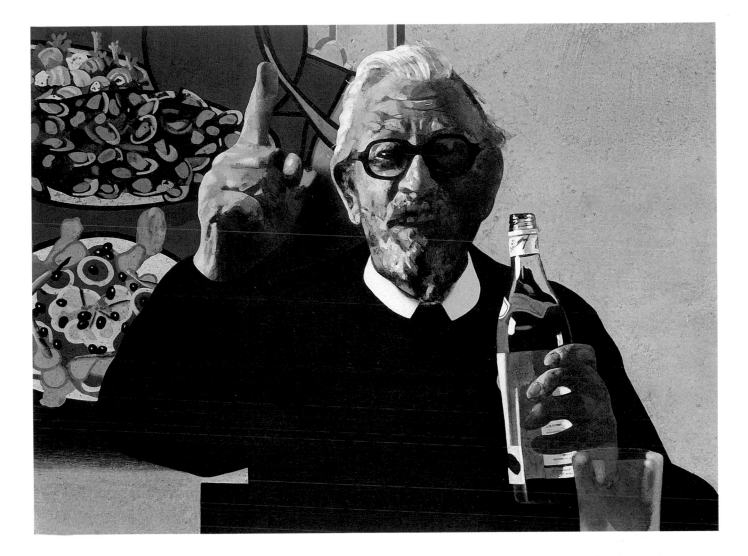

they mattered, or in certain cases, existed. I think he believed that artists and scientists had much in common. He told me of his meeting with Albert Einstein: various people were being introduced to the great physicist and each was allowed one question. Ted asked him about the Theory of Relativity:

'Did you go A, B, C... X?'
'Yes.'
'Why?'
'Because if I had not it would have taken four hundred years. I left it
 to others to fill the gap.'

I suppose Ted knew the answer in advance, but being him he would have wanted to have it confirmed. His support for certain artists at the right time in their development is part of the history of patronage, yet I have an idea that for Caulfield, Dubuffet, Francis, Hamilton, Jorn, Hodgkin, Kelly, Newman, Turnbull and others, his effect on them was much greater than that of a simple patron. W. H. Auden, writing of the poet W. B. Yeats after his death, stated, 'he became his admirers'. For his family and friends, Ted Power, this most private of men, lives on in the same way.

Peter Blake, *E. J. Power*, 1987–9, oil on hardboard 15.2 × 19 cm. Private Collection
The painting in the background is Patrick Caulfield, *Still Life Maroochydore*, 1980–1

THE CHALLENGE OF POST-WAR ART: THE COLLECTION OF TED POWER

Jennifer Mundy

> To me, one of the most fascinating aspects of a painting
> which I like is that it is an unique expression or statement of
> an artist's ideas and emotions communicated through colour,
> shape and texture, by him to me, in a form which I can
> hold, and keep, and own, and live with, and use, and enjoy,
> and perhaps with time to get to know and understand. This
> knowing of a picture should always be a challenge ...

[E.J. Power], *10 International Artists*, Norfolk Contemporary Art
Society, Norwich Castle Museum 1959

E. J. POWER (1899–1993), known always to his friends as Ted, was one of the great col-
lectors of post-war international art. From the mid-1950s, when Britain was slowly
emerging from years of austerity and isolation from developments in art abroad, Power
sought out the newest and most radical art he could find, in Paris, New York and
London. Teaching himself to discern what moved him and refining his eye for quality,
he bought great works by such artists as Dubuffet, Jorn, Tàpies, Rothko, Pollock, Kelly
and Barnett Newman, at a time when other British collectors and most museums and
commercial galleries knew next to nothing about them. He kept abreast of the latest
trends, and was a friend to many artists. He bought with passion: of Dubuffet, a painter
he admired enormously, he acquired over eighty works in the period 1955–60 alone.
Above all, he bought in a spirit of enquiry. As early as 1956, in the catalogue of an Arts
Council exhibition of works from Power's collection presented anonymously as *New
Trends in Painting: Some Pictures from a Private Collection*, Lawrence Alloway wrote of Power's
'experimental' attitude towards art: 'This collector ... may buy a picture to find out
what he really thinks about it. He buys new work while the paint is still wet, while the
aesthetic with which to describe and evaluate it is still in the making ... This anony-
mous collector works, one cannot help guessing, in the spirit in which his artists paint
– impulsively, experimentally, to see what will happen.' The result, Alloway said, was a
collection that was 'unique in England and impressive anywhere'.[1]

Nothing in Power's early life can be said to have foreshadowed his later passion for
art – except perhaps his determination to be at the forefront of his chosen field. He
was born to Irish parents in Clonfort, County Galway, and lived on the family farm
until 1907 when his father, an army sergeant, was transferred to mainland Britain. His
parents separated, and in 1910 his mother took the family of four children to
Manchester. It seems that the use of Morse code to arrest the infamous Dr Crippen on
board a transatlantic liner in the summer of 1910 sparked the young boy's imagina-
tion, and helped shape his conviction that radio was the thing of the future. As soon as
he left school he enrolled on a short private course to study radio, and then, still
aged only sixteen, joined the navy as a wireless operator. Over the next few years he

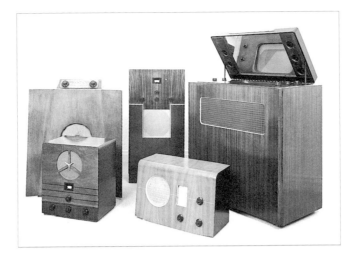

fig.1 Murphy Radio cabinets 1930-7, designed by R. D. Russell and manufactured by Gordon Russell Ltd

continued to study and gain practical experience of radio while at sea, before setting up as a manufacturer of crystal sets and transformers. In 1924 he married a young wig-maker and apprentice hairdresser named Irene Bevan, known always as Rene, with whom he was to have four children. For a period he worked as chief engineer for McMichael Radio, but then left to establish his own business in Slough, repairing wire-lesses and manufacturing inexpensive radio receivers.

In 1929 Power decided to join a family friend named Frank Murphy in setting up a new manufacturing firm. Unlike Power, Murphy had little practical experience of radio manufacture but believed that he could break into the market by producing reliable, competitively priced sets that performed well and were, above all, simple to operate. (Underlining the unnecessary complexity of current designs, the company used as one of its early advertising slogans, 'We were not blessed with three hands!') Murphy Radio, in which Power was a partner and chief engineer, was pioneering in its busi-ness philosophy, engineering and cabinet design: every aspect of the company's activ-ities – from the layout of the factory at Welwyn Garden City to the design of the cardboard boxes used to package the wirelesses – was scrutinised and evaluated afresh by Murphy and Power in the firm's early years.

A crucial element in the company's success was the determination of the two men to make rationally designed, modern-looking sets. They found out that the furniture manufacturer Gordon Russell was interested in modern design, and went to visit him and his brother Dick at their factory in Worcestershire. In his autobiography Gordon Russell recalled that Murphy and Power came wearing 'old mackintoshes and cloth caps and looking as if they worked round the clock'. With no time spent on formali-ties, Russell wrote, Murphy launched into a description of the problem: '"Look at this", he said to us, producing a portable cabinet, "It's just a box. No ideas. Ted and I have spent many hours trying to find out how we can keep these ugly knobs out of sight without making them inaccessible but we haven't got anywhere. We're at a dead end."' Russell believed that the question of the design of the cabinets should not be considered simply as an afterthought, as was the current practice, but in tandem with the engineering of the set as a whole. He and his brother Dick, who joined the design team at Murphy Radio, were responsible for the streamlined cabinets that became a hallmark of the firm's products. Initially, the new designs were not popular with deal-ers or the public, who were used to more ornate cabinets. However, the company had confidence in its sets and boasted of their 'outstanding design'; and in time the best of them came to be recognised as classics (fig.1). Looking back at his early meetings with Murphy and Power, Gordon Russell commented, 'To my surprise, the question of pub-lic acceptability never entered the discussion at this stage: they wanted to find the best possible solution, to tell the public about it and then they felt the public would accept it. They were pioneers, with a zest for the job, and that link held us together through several very tricky years.'[2]

Following Murphy's resignation, Power became chairman of the company in early 1937, and under his guidance, the firm prospered and retained its reputation for good-quality engineering and innovative design. During the Second World War Murphy Radio entered the field of military communication, developing high-performance radar valves. Thereafter, its electronic division continued to produce military, as well as medical and acoustical equipment. Expanding into the field of television manufacture, Murphy Radio enjoyed a boom period in the 1950s. The company had been floated on the stock market in 1949 and Power was now a wealthy man. By 1962, however, he was convinced that television manufacturers had to combine into fewer, larger units, and he allowed Rank Organisation to buy control of the company. In his retirement Power was able to devote more time to collecting art, already an absorbing passion.

THE VERY FIRST paintings bought by Power gave little hint of the future character of his collection. They were three small landscapes by the Norfolk school painters Cotman and Crome, discovered in an antique shop in Great Yarmouth during a family holiday in the mid-1940s. However, Power's tastes undoubtedly already ran towards the contemporary. The furniture at his home in Blakemere Road, Welwyn Garden City, was made by Gordon Russell, and in 1935 he had Dick Russell redesign the interior of the ground floor. It was about this time that Power acquired the two signed photographs by Moholy-Nagy, the Hungarian Constructivist artist and experimental photographer and designer, that hung in the Russell-designed dining room before the war. Moholy-Nagy lived in London between 1935 and 1937, and to help support himself worked as a window dresser at Simpson's department store in Piccadilly. According to the story Power told his son Alan, he bought the photographs after he had met Moholy-Nagy at Simpson.[3]

Power acquired his first modern paintings in 1951. In Ireland on a golfing holiday he visited Victor Waddington Galleries in Dublin, and there bought paintings by Daniel O'Neill and Jack Yeats.[4] Advised by Waddington the following year that there was to be an exhibition of O'Neill and another Irish painter named Colin Middleton in London, Power duly went and bought four more works at the gallery Arthur Tooth & Sons.

It was on this occasion that he met one of the young directors of Tooth's, Peter Cochrane, who was to become a life-long friend and play an important role in helping him build his collection. Cochrane would discuss possible purchases with Power, sometimes accompany him on trips to galleries abroad, and deal with the many practical matters relating to the payment and transport of works. When buying for Tooth's in Paris or New York, Cochrane and another partner named David Gibbs were keenly aware of what might interest Power, and often bought with him in mind. Power would be invited to see the best of the gallery's purchases as they arrived, and paid only 10 per cent above what the gallery itself had paid. Power bought from other galleries, notably Gimpel Fils, but Tooth's was, in effect, his main agent for buying paintings from abroad through the most important phase of his collecting.

Tooth's records show that Ted Power's early buying was catholic. In 1953, for example, he bought two more O'Neills, a Sickert, a Sisley and a flower piece by Matthew Smith. However, towards the end of that year he wished to try newer art and asked Cochrane to buy some abstract works for him. In November 1953 Cochrane bought from Gimpel Fils *Landscape* by Peter Kinley, *Beachscape, Incoming Tide* by Donald Hamilton Fraser, and *Abstract (19 Novembre 1951)* by the French painter Pierre Soulages. The first two were based on nature but, with their encrusted surfaces and de Staël-like use of slabs of colour, certainly looked more 'abstract' than any other works in Power's collection. The third was a truly non-figurative work by an artist who had become known outside Paris only recently. Some months later, in a characteristic move, Power asked Cochrane to buy another work by each of the three artists, so that he could come to understand better their aims and development.

By 1954 Power was beginning to buy in large numbers: the Tooth records alone reveal fifty-four purchases made in that year.[5] Although they included works by great

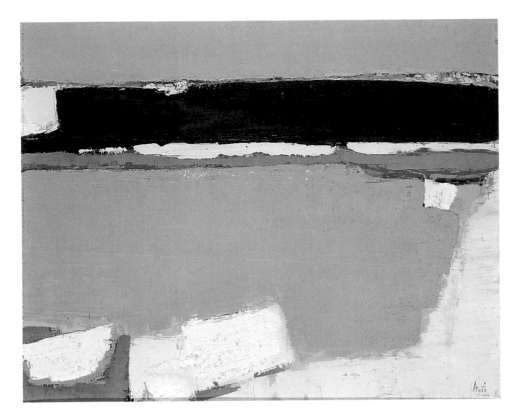

names – a Vuillard of 1890, and a Picasso of 1953 – the majority were by lesser-known contemporary French artists: there were five Clavés, for example, five Minauxs and four Brianchons. However, he also purchased from Paris nine paintings by de Staël – many of them from the artist's most recent, figurative phase – and a further ten over the next two years. This shows Power's commitment to an artist who was seen by many critics as the most original painter to have emerged in Paris since the war and whose work, exhibited in London for the first time in 1952, had already proved enormously influential on younger British artists.[6]

If de Staël was already something of a 'name' in England when Power bought him, Dubuffet, an artist whom he began to purchase in November 1955, was hardly known. Dubuffet's first show in this country was held at the Institute of Contemporary Arts (ICA) in March–April 1955, and was ignored – a reception that Lawrence Alloway later described as 'the British equivalent of an art scandal'.[7] Dubuffet's fascination with the art of children and the mentally ill allowed his work to be seen in England as a

13

development of Surrealism; and it is perhaps significant in this context that two works in the ICA exhibition were owned by collectors associated with Surrealist art, Roland Penrose and Peter Watson. However, the catalogue preface, written by the French critic and friend of the artist, Georges Limbour, emphasised Dubuffet's novel approach to matter – for example, his use of thick pastes, incorporating tar and cement, instead of oil paint – rather than his imagery or style. Dubuffet's paintings, he said, offered a new way not only of understanding but also of directly experiencing the world. The text also stressed that Dubuffet's works could not be appreciated or understood singly: 'Each one of his paintings', wrote Limbour, 'derives its meaning from those preceding it, which it either contradicts, completes or supplements. In a way, each one is a moment in a pictorial adventure, an episode, or else a detached phrase, complete in itself, from a long poem, each fragment of which becomes clearer as one gets to know the work as a whole.' It is likely that Power – who not only bought eighty works in the space of five years but also went on to buy (and sell) Dubuffets for the remainder of his collecting career – shared Limbour's view that Dubuffet's art could only be grasped by following his development through a number of works. Power's policy of collecting individual artists in depth – great depth in the cases of artists he admired particularly – had little precedent in the history of collecting in Britain, and was perhaps fuelled by his desire, as he said in 1959, to 'get to know and understand' an artist's ideas.[8]

IN THE MID-1950s Power travelled regularly to Paris to buy art, often in the company of Peter Cochrane. It was on their trips that he met and became close friends with Dubuffet and the Danish Cobra artist Asger Jorn, both of whom spoke English. In conversation in 1982 with Guy Atkins, an expert on Jorn, Power recalled a visit to Dubuffet's studio that he had made with Rene, Lawrence Alloway and his wife Sylvia Sleigh, and Peter Cochrane, during which they were involved in an experimental music session, along with Asger Jorn:

> Dubuffet went on the double bass. Asger was on a little harmonium in the corner. And then Sylvia, Lawrence, Peter, Rene and I were given a long table where we found some little pipes, silver paper to shake, rattles and God knows what … It was marvellous because at first it was just cacophony. We were roaring with laughter. Dubuffet wasn't laughing, he was deadly serious. But Asger from his corner was winking at us. The odd thing was that after about five minutes it all dropped into place and everybody was doing things at the right moment and it wasn't bad.[9]

Power became a great friend of Jorn: in later years he frequently invited him to his flat in Grosvenor Square where they talked for hours over whisky or brandy. However, he had begun purchasing Jorn's work before he had met him, having come to the view that he was the best of the artists associated with the Cobra movement. 'For me Asger had something new, something lively', he explained to Guy Atkins. 'It was figurative work but not figurative in the ordinary sense. It was an abstract look at life … In my view Asger paints the emotion *behind* the figure. This is the distinction I noticed at the time. Dubuffet is the same.'

Tooth's records show that between November 1956 (that is, before the exhibition in June 1957 at the Galerie Rive Gauche that marked the beginning of the Danish artist's success on the French art scene) and November 1960, Power purchased no less than twenty-nine works by Jorn. His faith in Jorn was shared by Lawrence Alloway, who not only wrote a catalogue text for an exhibition of his work at Tooth's in early 1958 and organised a retrospective at the ICA later in the same year but also considered writing a book about him.[10] In 1961 Power bought a further three paintings from the sell-out show of Jorn's recent 'Luxury' or drip paintings at Tooth's; but he was not happy with this new phase of his friend's work. To Guy Atkins he said, 'We went to see Asger at the time of the drip pictures. I was disappointed, but he was very happy about them when Peter Cochrane and I saw him in Paris. It wasn't for me to say that I did not like what he was doing. After all, the artist is entitled to do what the hell he likes.

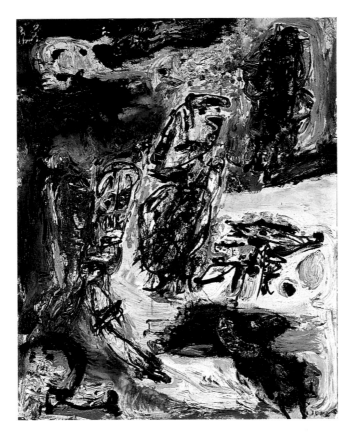

But it isn't necessary for me to follow him.' Referring to one of the 'drip' paintings, he added, 'I bought *Chaosmos* deliberately, in order to hang it and find out what's the matter with me, Why don't I like it? I never did like it.'

POWER had no interest in self-publicity, and preferred not to draw attention to his collecting. From the mid-1960s he lent works to exhibitions only anonymously, and although he welcomed many artists and collectors to his home to see his paintings, the full scale and importance of his collection was not appreciated even inside the circle of his friends and acquaintances. In the mid to late 1950s, however, he allowed parts of his collection of contemporary art to be exhibited, first in a touring show organised by the Arts Council in 1956–7, then at the ICA in 1958, and finally in a small display at Norwich in 1959. (Only in the case of the ICA show, however, was his name revealed.) Power agreed to these exhibitions in order to help make the radically new type of art he liked better known – or, as he wrote in the Norwich catalogue, 'in the hope that there may be some among those who come to see them who will be receptive, rather than intolerant, and will allow the pictures themselves a chance to exert their very real authority, and thereby share with me some of the exhilaration and pleasure I have found in them'.[11] He may also have felt it important to support the efforts of those relatively few institutions prepared to champion contemporary international art. He later commented, 'I did those early exhibitions because I was the only *modern* collector in England. It sounds terribly vain. I don't like the "I'm first" business. I'm only saying it because in those days it was important for the ICA and the Arts Council to be recognised as having a modern outlook.'[12]

The Arts Council show *New Trends in Painting: Some Pictures from a Private Collection* featured twenty-seven works by nine artists: Karel Appel, Bram Bogart, de Staël, Dubuffet, Max Ernst, Sam Francis, Paul Jenkins, Jean-Paul Riopelle and Soulages. It travelled to Cambridge, York and Newcastle, and proved so popular that the Arts Council hurriedly arranged a showing in London in the early summer of 1957, where it drew an audience of 3,500. Described by the critic David Sylvester, writing in the *Listener*, as 'one of

the best exhibitions of post-war painting to have been seen in this country',[13] it was, for many people, the first chance they had to discover what had been happening in the studios of Paris since the war. (All of the nine artists were living at this time in Paris.)

Alloway provided an incisive essay for the catalogue entitled 'The Challenge of Post-War Painting'. In this he argued that the work of the nine artists in the show formed part of a new post-war movement. Although variously labelled 'action painting', 'l'art autre' or 'tachisme', this movement could be broadly characterised, he wrote, by a new approach to paint and to the process of painting. 'The highly developed feeling for paint', he said, 'commits the artist to a new approach to painting. Each picture must be read as a record of the artist's actions while producing that painting.'[14]

Alloway became a close friend of Power. They met regularly to discuss art, and it seems likely that Alloway – who through his art criticism and position as Deputy Director of the ICA was an extremely influential figure in British art – helped shape Power's understanding of the work being produced in the period. Certainly, it is possible to detect echoes of Alloway's words in the few published statements made by Power at this time. The term 'challenge', for example, which was used by Alloway in the title of his essay for the Arts Council exhibition, was also to be used by Power in his text for the 1959 Norwich exhibition, when he wrote, 'knowing a picture should always be a challenge'. The idea embodied in the quotation from Karel Appel, 'Painting is a tangible, sensory experience', used by Alloway as the epigraph to his Arts Council essay, was closely echoed by Power in the 1958 ICA catalogue: when asked what in his view the paintings represented, he was quoted as saying, 'By gestures or symbol they record man's reaction to a world teeming with events. The impact of these events is all stronger for being sensed or felt rather than recorded visually.'[15] Furthermore, like Alloway, Power shifted his sympathies in the mid-1950s away from the School of Paris to American art, retaining his enthusiasm only for Dubuffet, de Staël and early Jorn. However, Power was a man to make up his own mind about art, and it is quite likely that as by far and away the most important collector of contemporary painting in Britain, Power helped Alloway by telling him about artists that he had discovered and showing him works that he might not otherwise have been able to see.[16]

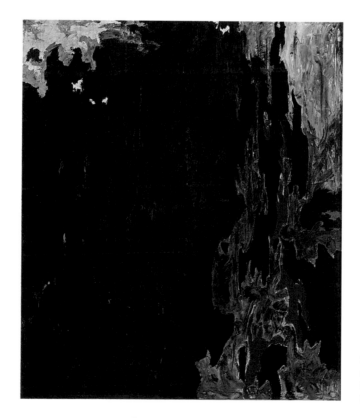

fig. 5 Clyfford Still, No. 21, 1948, oil on canvas 175.3 × 151.4 cm. Private Collection
Purchased by E.J. Power Jan. 1957

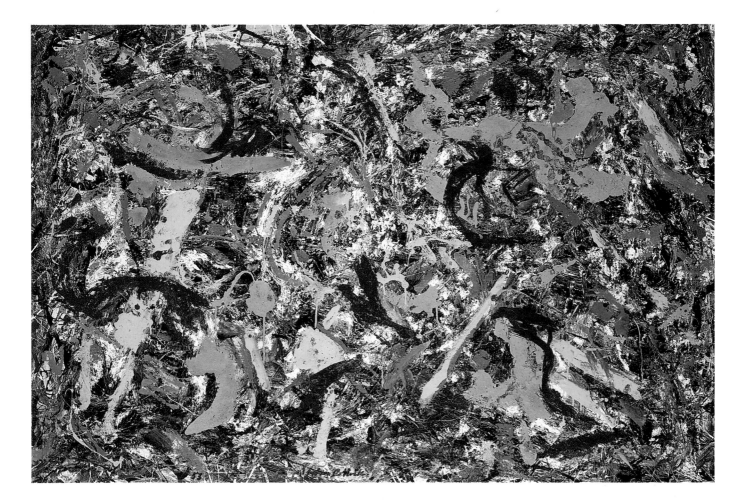

fig. 6 Jackson Pollock, *Unformed Figure*, 1953, oil on canvas 132 × 195.5 cm. Private Collection
Purchased by E.J. Power Jan. 1958

THE SHIFT in Power's tastes towards American Abstract Expressionism began after the important exhibition of modern American art held at the Tate Gallery in January–February 1956. The show contained relatively few truly contemporary works but it did have some major pieces by de Kooning, Still, Rothko and Pollock, and had a great impact on British art.[17] In 1956 Power bought works by Sam Francis, an American artist then living in Paris, and also a Rothko of 1949. In January 1957 he bought *Banners of Spring*, 1946 by Jackson Pollock and *No.21*, 1948, by Clifford Still (fig.5). In August he bought de Kooning's *Woman* of 1955, two Rothkos and a Kline. In January 1958 he acquired another Still, two Klines and two more Pollocks, including the magnificent drip painting *Unformed Figure*, 1953 (fig.6). Power himself did not go to New York until 1964, and his American paintings were, with very few exceptions, bought by Peter Cochrane or David Gibbs, who acquired them in order to sell on to Power.[18]

Power's recent American acquisitions were among the stars of the show organised by Lawrence Alloway for the ICA in March–April 1958, *Some Paintings from the E.J. Power Collection* – a show that consisted of eleven works in total by de Kooning, Dubuffet (represented by the recently acquired *Large Black Landscape*, 1946, p.28), Tàpies, Kline, Pollock, Rothko and Still. These were the artists that Power and Alloway evidently felt were the most important in the contemporary scene. The show predated by a year the exhibition *The New American Painting* – organised by the Museum of Modern Art and held at the Tate Gallery – which signalled the supremacy of New-York based art over the School of Paris, and to which Power was the sole British lender. He also made an important, but, as ever, anonymous, contribution to the costs of the fully illustrated catalogue.[19]

Not included in the 1959 Tate exhibition but already strongly represented in Power's collection was an American hard edge abstract painter named Ellsworth Kelly. Kelly –

who lived in Paris between 1948 and 1954, and had exhibited at the Betty Parsons Gallery, New York, in 1956 and 1957 – had sold a few paintings, including one to the Whitney Museum of American Art; but nothing anticipated the success of his show at the Galerie Maeght, Paris, in November 1958. Power happened to be in Paris with Peter Cochrane at the time, and together they chose no less than eight canvases by this relatively unknown artist, including *Broadway* (p.40). According to the story told to Kelly by Alloway, Power was so excited by the show that he invited Alloway and his wife to come to Paris and see the works at Power's expense. On his return to London, Power was still not satisfied, and attempted to acquire three more works from the show. [20]

An American artist with whom Power developed a particularly close friendship was Barnett Newman. Newman was represented in the 1959 Tate exhibition by three works, one of which was *Adam*, 1951–2 (acquired by the Tate in 1968). In December 1959 David Gibbs, then an independent dealer, bought the companion work *Eve* (p.36) directly from Newman with a view to selling it to Power. A little later, in March 1961, he also bought for Power *White Fire I*, 1954. Power's son Alan, who visited New York on business, had in the meantime become friends with Newman; and in 1964 bought *Uriel*, 1955, from him. After the painting had been shipped to England, Newman became nervous about the necessary restretching of the eighteen feet wide canvas, and Alan persuaded him to come to London to oversee the work. Newman and his wife Annalee then met Ted and Rene, who threw a party for them and showed them London. [21] Shortly afterwards the Powers went to New York on what was their only trip to the city, and spent time with Barnett and Annalee. Power admired the newly completed painting *White Fire III*, 1964 in the studio, and prevailed upon the artist to let him buy it, even though no one had else had yet seen it. Although Power and Newman met each other only on a few occasions thereafter, they corresponded frequently and had the highest regard for each other. [22]

In 1959 Power and his wife moved from Welwyn Garden City to a large flat in Grosvenor Square, London, which they had refurbished by Dick Russell. With its hidden lighting system, plain wooden panelling and large open spaces, it was designed to suit Power's modern collection. Relatively few works could be displayed there, but artists who visited the flat in the early days recall the impact made upon them by seeing there single works occupying whole walls in a domestic environment. [23] Power experimented with different arrangements of works in his flat but in his last years visitors could expect to see at the far end of the living room a stunning grouping of Newman's *White Fire III*, *Untitled*, 1948, by Pollock, and Brancusi's *Fish* (p.24), one of the very few major pieces by the Romanian sculptor held in private hands in England (see frontispiece). Through his assiduous gallery visiting, Power came to know many of the artists well, and would visit them in their studios or invite them to his flat. [24] There he would spend hours discussing with them various topics in the arts and sciences, demonstrating a versatile intelligence, independent judgement and humour that inspired affection and respect.

Power was particularly friendly with William Turnbull – whom he met at a gallery opening in the mid-1950s – and his wife the sculptor Kim Lim. Turnbull recalls that Power bought some of his early sculptures and paintings, and sometime before 1959 invited him to work alongside the design team at Murphy Radio. Power had nothing specific in mind for Turnbull to do, but felt it would be stimulating for his design team to work with an artist. So, once a fortnight for a period of three months, Turnbull travelled to Welwyn Garden City, and worked on the design of two television sets. One was to have a transparent case, he recalls, while the other was to be covered with 'blue goat skin or something exotic'; and both were to be placed on pull-out tracks. They were never meant for production, and Turnbull describes the experience as an early example of Power's attachment to the concepts underlying chaos theory. (It was symptomatic of Power's intellectual curiosity that he retained a lively interest of scientific and philosophical ideas throughout his life.)

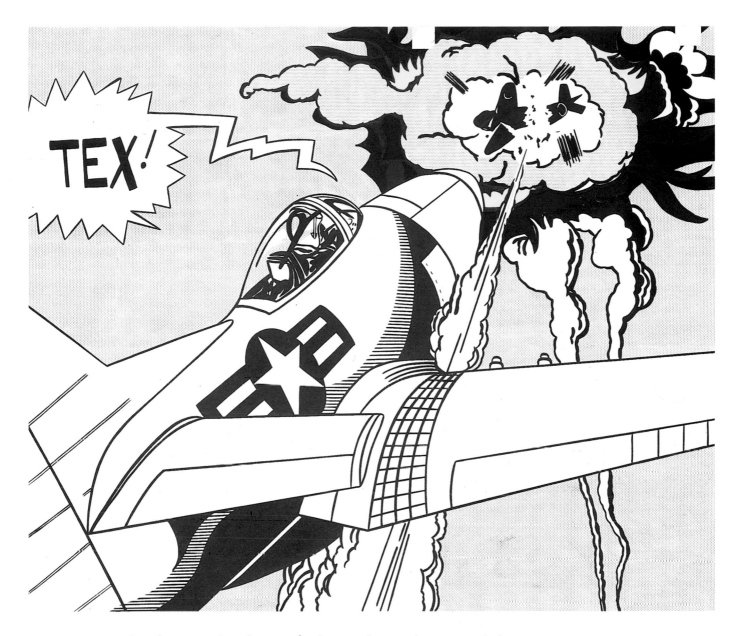

fig. 7 Roy Lichtenstein, *Tex!*, 1962, oil
on canvas 173 × 203.5 cm. Estate of
E.J. Power
Purchased by E.J. Power March 1964

POWER acquired works across a broad range of stylistic tendencies; the common link between them was his interest in whatever was most up-to-date. He bought paintings by R.B. Kitaj in 1961, and by Allen Jones and Peter Blake in 1962–3; and in December 1963 he bought an important early Howard Hodgkin entitled *Gardening*, 1960–3, before it was exhibited as the centrepiece of the artist's show at Tooth's in January 1964. However, he bought a work only when he himself was convinced by it. Richard Hamilton, one of the key figures in the Independent Group and British Pop movement, recalls how he had known Power well for many years before Power asked to buy one his paintings: 'I asked him "why now?" He said that he had read a piece by me in *Living Arts* 2 (published in 1963) and thought he should have something, indeed he asked my advice, and took it, on which work I would buy if I were him. I still questioned the reason for the conversion and he said that before he read the article he "didn't know I was serious".'[25] The painting Power bought was *Hommage à Chrysler Corp.*, 1957 (p.38).

During the 1960s Power continued to buy modernist works of an earlier period; but, with a few notable exceptions, he tended to avoid the great names from the first part of the twentieth century, focusing instead on lesser known and relatively under-

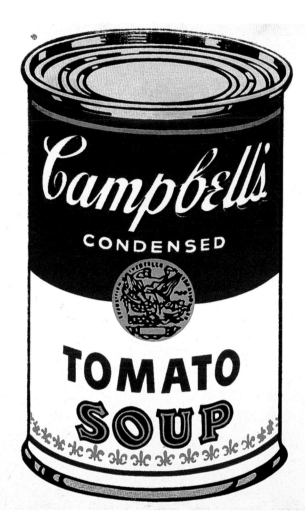

fig.8 Andy Warhol, *Soup Can*, 1964
silkscreen on canvas 91.4 × 61 cm.
Private Collection, Sweden
Purchased by E.J. Power *c*.1964–5

valued artists such as the Italian Futurist Giacomo Balla and the Russian Natalya Goncharova. In 1959 he acquired his first paintings by the Dada artist Francis Picabia, and lent no less than ten works, including *The Handsome Pork-Butcher* (p.27), to the Picabia exhibition held in Newcastle and then at the ICA in 1964.[26] For an exhibition of works owned by Friends of the Tate Gallery in 1963, Power chose a small group of works by Delaunay, Goncharova, Mondrian, Picabia and Severini.[27]

Increasingly, however, Power's collection centred on contemporary American art. In terms of both quality and quantity, it was by and far away the most distinguished collection of its kind in Britain. It is difficult to establish now exactly what he acquired, but it is known that in 1964–5 he bought *Counter and Plates with Potato and Ham*, 1961 by Oldenburg (p.46), *Tex!*, 1962 (fig.7, p.19) and *Wall Explosion II*, 1965 by Lichtenstein (p.51), *The Space that Won't Fail*, 1962, by Rosenquist and *Soup Can*, 1964 by Warhol (fig.8).[28] He was to own a number of other major early Warhols, including *Troy*, 1962, *Blue Electric Chair*, 1963, *Flowers*, 1963, and *Merce*, 1963. As ever, his purchases revealed the catholicity of his taste, and he bought not only Pop art but also such colour field painters as Morris Louis and Ad Reinhardt, and the hard edge painters Josef Albers and Kenneth Noland.

Although Power continued to buy until the very last years of his life, and kept up to date with the latest movements in art, he no longer seriously attempted to collect the best of current work. The ending of this phase in his collecting coincided with his appointment in 1968 as a Trustee of the Tate Gallery. As early as 1962 Power had attempted to strengthen the Tate's holdings of avant-garde British art by donating a group of works by Turnbull, Stroud and Plumb (pp.43, 50, 52), artists who had taken

part in the 1960 *Situation* exhibition, together with *Broadway* by Ellsworth Kelly (p.40). During his seven-year Trusteeship Power argued with fellow Trustees twenty years his junior for a more adventurous acquisition policy, and continued to supplement the Tate's purchases by gifts of work by young artists. In 1974 the Trustees declined to buy *Fat Battery*, 1963 (p.54), a work by the German artist Joseph Beuys consisting of a small cardboard box with elements made of tin, felt and fat, because of the inherent diffi-culty of conserving such a piece. Convinced of the importance of Beuys's work, Power bought *Fat Battery* himself, thereby securing its future in this country, and immediately offered it to the Tate as a loan – a solution that was gratefully accepted. Ten years later Power presented the work to the Gallery as a gift. In 1980 he allowed the Tate to pur-chase at a reduced price a group of important works including *Monsieur Plume with Creases in his Trousers (Portrait of Henri Michaux)* by Dubuffet and Barnett Newman's *Eve*, which are among the highlights of the post-war collection (see pp.30, 36).

WHEN POWER was asked, near the end of his life, what he thought art was, he replied using a scientific vocabulary that came naturally to him 'transmission of ener-gy'.[29] Certainly, he expected art to move him both emotionally and intellectually, and he sold works that failed to do so or which he felt had no more to offer him. Artist friends recall with affection not only his ability to discriminate the good from the bad, but also his unwavering belief in the vital importance of contemporary art. Why such discrimination and belief were so rare among British collectors at the time is hard to explain;[30] but the fact remains that Ted Power was a pioneer in his collecting, whose adventurous purchases of avant-garde international art and quiet support of younger British artists, and determination to trust his own judgement and not to be bound by conventional tastes, made him an unique figure in the history of post-war British col-lecting.

ACKNOWLEDGMENTS

In writing this essay I have been greatly helped by those who knew E.J. Power. I should like to express my thanks above all to his family – Derek and Alan Power and Janet McIntyre – for allowing me access to personal papers and for talking to me freely about their memories of their father. I am profoundly grateful to them. I should also like to express my gratitude to Leslie Waddington for his help and encouragement. Simon Matthews provided invaluable assistance in allowing me access to Tooth records, and Trevor Chinn and Ray Leigh of the Gordon Russell Trust, Pamela Griffin, David Mellor, Henry Skinner, Anthony Smallhorn and Norma Watt in different ways kindly helped establish particular facts. Many close to Power freely gave of their time to share their reminiscences. They include Peter Cochrane, Kay Gimpel, David Gibbs, Nigel Greenwood, Lord Renfrew, Sylvia Sleigh, Annalee Newman, Ellsworth Kelly, William Turnbull, Kim Lim, Richard Hamilton and Sir Howard Hodgkin. It is a mark of the stature of this modest and discreet collector that so many remembered him with both warmth and admiration.

1. Lawrence Alloway, 'Introduction: The Challenge of Post-War Painting', *New Trends in Painting*, exh. cat., Arts Council, Arts Council Gallery, Cambridge, Oct.–Nov. 1956, City Art Gallery, York, Nov.–Dec. 1956, Walker Art Gallery, Liverpool, Dec. 1956–Jan. 1957, Hatton Gallery, Newcastle, Feb.–March 1957, Arts Council, London, May–June 1957, p.5.

2. Quoted in Joan Long, *A First Class Job! The Story of Frank Murphy, Radio Pioneer, Furniture Designer and Industrial Idealist*, Sheringham, Norfolk 1985, pp.59–61. For discussion of the history of Murphy Radio see also Keith Geddes and Gordon Bussey, *The Setmakers: A History of the Radio and Television Industry*, London 1991. The company's boast about the sets' 'outstanding design' is found in an advertisement of 1931 reproduced in Long 1985, p.64.

3. The photographs were *Cat Negative*, c.1926, and *View from a Rooftop*, c.1929 (estate of E.J. Power).

4. *Harvesters* by O'Neill, and *Westward* and *A Challenge* by Yeats. The latter was to hang in Power's bedroom through his life.

5. The figures for following years are thirty-six works in 1955 (including a Bonnard nude and a sculpture by Giacometti), fifty-three in 1956 (including a Monet of 1886, and three Tàpies, an artist recommended to Power by Cochrane), sixty-nine in 1957 (including the Tàpies work *Grey and Green Painting*, which the Tate Gallery was to buy from Marlborough Fine Art, London, in 1962), forty-seven in 1958, forty-one in 1959, fifty-six in 1960 (including a group of works by Josef Albers), thirty-three in 1961, thirty-four in 1962 (including three works by Cy Twombly, another artist first recommended to Power by Cochrane). These records do not reveal the full extent of Power's purchases, particularly in the latter period when Power bought increasingly through other galleries or directly from artists. It is important to note that Power sold almost as much as he bought, particularly in the years of his retirement.

6. 'None of those who saw it will ever forget the exhibition that Nicolas de Staël had at the Matthiesen Gallery in London in February 1952. For the artist himself it was his most important exhibition to date, and the first of any consequence outside France ... Several British artists fell immediately under his influence: his thick impasto and sensuous handling of the paint were imitated, and the kind of abstract painting that his work of 1948–52 represented seemed to offer an example that was particularly relevant to those younger British painters then on the verge of abstraction but also reluctant to lose all contact with nature and the figure.' Alan Bowness, 'Introduction', *Nicolas de Staël*, exh. cat., Galeries nationales du Grand Palais, Paris, May–Aug. 1981, Tate Gallery, London, Oct.–Nov. 1981, p.5.

7. Lawrence Alloway, 'Dubuffet as Pastoral', exh. cat., *Jean Dubuffet: Eléments botaniques (Août–Décembre 1959)*, Arthur Tooth & Sons Ltd, London, May–June 1960, p.4.

8 See quotation at beginning of essay.

9. Typescript of conversation between Power and Guy Atkins on 2 Feb. 1982, revised and approved by Power.

10. See Guy Atkins, *Asger Jorn. The Crucial Years: 1954–1964*, London 1977, p.134.

11. [E.J. Power], 'Collectors Foreword', *10 International Artists*, exh. cat., Norfolk Contemporary Art Society, Norwich Castle Museum 1959. My thanks to Norma Watt of the Norwich Castle Museum for ascertaining the date of this publication. The ten artists included in the exhibition were Karel Appel, Norman Bluhm, Bram Bogart, Jean Dubuffet, Sam Francis, Paul Jenkins, Asger Jorn, Jean-Paul Riopelle, Nicolas de Staël and Antonio Tàpies.

12. Atkins 1972.

13. David Sylvester, 'Round the Galleries', *Listener*, London, 25 Oct. 1956.

14. Alloway 1956, pp.2–3.

15. Lawrence Alloway, 'Notes on the Paintings', *Some Paintings from the E.J. Power Collection*, exh. cat., Institute of Contemporary Arts, London, March–April 1958, [p.1].

16. Sylvia Sleigh, Alloway's wife, has written: 'Although he [Power] consulted Lawrence, he had great taste of his own and I think that they had many fascinating discussions'. She recalled, too, that Power lent Alloway for a period a large Sam Francis, one of the first works by an American artist he bought (text sent with letter to the author, dated 13 May 1996).

17. Three works by Jackson Pollock, all of 1949 and including one that measured nine feet by eighteen feet, had been shown in the exhibition *Opposing Forces* at the ICA in 1953, but it as not until the 1956 Tate show *Modern Art in the United States: A Selection from the Collection of the Museum of Modern Art, New York* that people in Britain had much opportunity to see recent American painting.

18. Alan Power also bought works for his father while on business in America.

19. My thanks to Pamela Griffin of the Arts Council Archive, at the Hayward Gallery, London, for patiently checking the records to establish Power's identity as the anonymous donor to the costs of the catalogue. Power lent to the exhibition Sam Francis's *Blue and Black*, 1954.

20. Letter from Peter Cochrane to Ellsworth Kelly, 10 Dec. 1958. In 1995 Kelly presented a suite of four prints to the Tate Gallery in remembrance of Power, whose early buying of his work had given his career such an important boost.

21. While it is not clear what contact there had been between Newman and Ted Power before 1964, there must have been some. Newman wrote to Power on 8 July 1962, asking him to exert his influence in a quarrel with the *Listener* and taking the opportunity, as he wrote, 'to express to you how very moved I have been by your interest in my work. I feel we know each other'.

22. My thanks to Annalee Newman for explaining the sequence of events. The warmth of the friendship between Power and Barnett Newman can perhaps be best illustrated by a passage from a letter written by Newman on his return to New York on 2 July 1964: 'Annalee and I cannot possibly express our thanks for the delight and pleasure we had spending our trip with you and Rene and with Alan and Joy. For no matter what else happened we feel that our trip was really a visit with you'. He continued, 'We think of you constantly and miss you both very much. We are hoping to figure something out so that we can return to London soon'.

23. 'In that setting [Power's flat in Grosvenor Square], the most striking impression made on young artists was the fact that a single painting could occupy the entire wall from floor to ceiling. For them, the sheer physical impact of the canvases invited comparisons with the cinema screen, or with the architectural environment, encourging modes of attention that slipped sideways into place and context'. Thomas Crow, 'London Calling', *Artforum International*, New York, Summer 1993, p.83.

24. For example, Power bought *Image of the Fish God No.7* (p.42) when he went to Alan Davie's studio in Hertfordshire and saw the still incomplete series of paintings. A story told by Barrie Cook about the purchase of *Painting, 1970* (p.58), illustrates the assiduousness of Power's gallery visiting:

Painting, 1970, was first shown at the Axiom Gallery in October 1970. Ted Power came to the private view and was actually standing in a wet raincoat on the doorstep of the Axiom the following morning when I arrived to clean up all the mess: bottle tops, broken glasses etc. Not knowing who he was and thinking he was simply standing out of the rain, I went into the gallery, closed the door and got on with the cleaning job. Antoinette Godkin arrived about ten past ten and immediately went into heavy conversation with this fellow who purchased the painting there and then for £300 but insisted that one of the drawings which related to the painting was thrown in for good measure. He asked to be introduced to the painter and was, I think, a little surprised when Antoinette brought him to the

ground floor of the gallery since I was caught doing the chores. A likeable man who wanted very much to talk about Barnett Newman, referred to as 'Barney' throughout the entire conversation. Naturally I was overjoyed that a painting should be sold within half an hour of the gallery opening for my show. I later discovered that he was quite a big collector of work and had the privilege when I took the painting to his flat, to stand in front of so many pieces of work by well known artists. It gave me a bit of a lift to be part of that collection. (Letter to the Tate Gallery, 7 May 1974)

25. Letter to the Tate Gallery, 3 July 1996.

26. Tooth records show that Power first purchased Picabias in June, August and October 1959, that is, before the Picabia exhibition at the Matthiesen Gallery, London, which took place in Oct.–Nov. 1959.

27. *Private Views: Works from the Collections of Twenty Friends of the Tate Gallery*, Tate Gallery, London, April–May 1963.

28. The phrasing of a letter Power wrote in June 1993 suggests that he may have bought this work directly from the artist: it was purchased, he wrote, 'by me from Andy Warhol in either 1964 or 1965 and then billed to me through the Sonnabend Gallery'.

29. Conversation with Kim Lim, 16 May 1996.

30. In *Private View*, a book giving an 'insider's view' of the British art scene, John Russell complained, 'The truth about the last twenty years is that a great many people had the money to buy important works of art, and that important works of art were quite easy to come by. What we lacked was judgement, appetite, pertinacity and flair.' He continued, 'plenty of people in London could have afforded to buy 20th-century art as skilfully as Hermann Rupf in Berne or Raoul la Roche in Basle: but it is only since 1945, in the person of Mr E.J. Power, that anyone in this country has shown comparable pioneering quality'. (Bryan Robertson, John Russell, Lord Snowdon, *Private View*, London 1965, p.14)

CONSTANTIN BRANCUSI
1876–1957

Fish 1926
Poisson

Brancusi was an artist who worked in series, returning to a small number of motifs time and time again in order to develop and reinterpret his vision of a subject. However, he made, for him, relatively few sculptures based on the slender form of a fish. The first, dating from 1922 (fig.9), was a veined marble work set on a circular mirror, which in turn was supported by a carved oak base. Two years later Brancusi made two hand-finished bronzes of similar size, one of which was destroyed, while the other has lost its original base. In 1926 he made a further three bronze *Fish* pieces, each of which has a quite different wooden base. All but one of the five bronzes were mounted onto reflective metal discs, echoing the very first piece. After an interval of four years Brancusi returned to this subject, producing a large work in blue-grey marble, set on a white marble and limestone base (Museum of Modern Art, New York).

Central to these works is Brancusi's novel expression in sculptural form of the experience of horizontal movement. The 'fish', which is fixed to the disc in such a way as to allow it to be rotated, is rendered as a very pure, streamlined form; so streamlined, indeed, that, when viewed from a certain angle, it almost disappears. The play of light on the bronze and on the metal disc makes the fish seem to lack substance and identity. As Brancusi reportedly said to a visitor to his studio *c.*1939, 'When you see a fish, you do not think of its scales, do you? You think of its speed, its floating, flashing body seen through water ... Well, I've tried to express just that. If I made fins and eyes and scales, I would arrest its movement and hold you by a pattern, or a shape of reality. I want just the flash of its spirit'. Earlier, in 1919, he said, 'We do not see real life except by reflections'. It seems likely that Brancusi's use of polished bronze was intended to make reflections an integral part of his sculptures.

Supporting the bronze 'fish' is a three-part base comprising the reflective disc and a wooden pedestal standing off-centre on a black metal disc. Brancusi often experimented with different combinations of sculptures and bases; a photograph, taken in his studio *c.*1928, shows this three-part base supporting the ovoid sculpture *Newborn*, while next to it stands an example of *Fish* on a stone base. *Newborn* was eventually set on a wooden base with a large central cavity (suggestive perhaps of a womb), similar in shape to the hole in the base of *Fish*.

The bases of Brancusi's sculptures were never intended to be merely functional. 'The pedestal', he once said, 'should be part of the sculpture, otherwise I must do without it completely.' In contrast to the simplicity and symmetry of the 'fish', this base combines different materials, technologies and textures; it also creates an overriding impression of asymmetry. Such a conjunction of different formal principles and media was not uncommon in Brancusi's work. Despite his reputation for being a sculptor who created simplified, unitary forms, the bases of many of his works suggest a deliberate courting of disjunction, or what a recent commentator has described as a 'thwarting' of 'our yearning for coherence'. As totalities, however, the sculptures and their bases create a tense interplay of ideas that give the works their characteristic vitality.

JM

Polished bronze on three-part base of polished metal, oak and black metal
polished bronze 12.5 × 41.5 × 3 (5 × 16¼ × 1⅛); polished metal disc 0.5 × 50.2 (⅛ × 19¾); oak (max. diameter) 79 × 41; (31⅛ × 16⅛) black metal disc 0.4 × 36.8 (⅛ × 14½) overall height 93 (36⅝)

Provenance
. . . Mr and Mrs Lee A. Ault, New York, when exhibited at the Staempfli Gallery, New York, Nov. 1960; bought by Otto Gerson, New York, Oct. 1962, who sold a ?part-share to Wilhelm Grosshenig, Düsseldorf, Jan. 1963; bought through Marlborough Fine Art Ltd, London, by E.J. Power July 1963

Accepted by the Commissioners of Inland Revenue in lieu of tax and allocated 1996

fig.9 *Fish*, 1922
marble 13.3 × 42.9 cm;
mirror 43.2 cm diameter;
oak base 61 cm high.
Philadelphia Museum of Art:
The Louise and Walter
Arensberg Collection

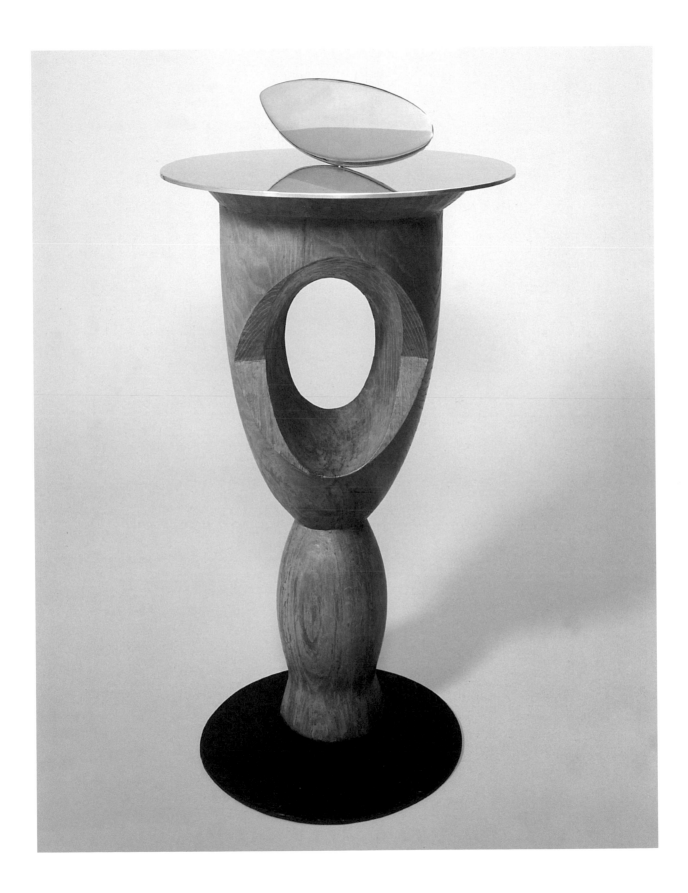

FRANCIS PICABIA
1879–1953

The Handsome Pork-Butcher c.1924–6, c.1929–35
Le Beau Charcutier

This painting has an extraordinary history, one which encapsulates themes central to Picabia's approach. In its earliest state it was an irreverent picture of a pink-faced man, wearing a white shirt and a black suit. Although dated 1921 on the stretcher, it is thought to be one of a group of works with collaged elements made by Picabia in the mid-1920s. As an early photograph shows (fig.10), Picabia used string and short plastic combs in the man's hair, darning needles for the eyebrows, toothpicks for the moustache and goatee beard, curtain rings for the eyes and mouth, measuring tape for the nose, and an array of pen-nibs in the area of the figure's bowtie.

It is possible that initially this work was intended as a satirical portrait of the prominent French intellectual and politician Raymond Poincaré, a Member of the French Academy, President of the French Republic 1913–20 and Prime Minister in 1922–4 and 1926–9. Certainly, it was described as such in a letter by the artist El Lissitzky in 1926, the year in which the canvas was first shown. However, in the following year the painting was exhibited simply as *Portrait*. It is therefore not clear how seriously or for how long Picabia himself regarded the work as a portrait of Poincaré. In 1928 the painting was reproduced in the British periodical *Artwork* with a frame of sandpaper and corrugated cardboard made by the designer Pierre Legrain. An accompanying article commented: 'Picabia's use of materials other than oil-paint, as in the portrait reproduced, with its combs, pins, etc., surely needs no defence. It is a trick of course, as the application of gold and jewels to mediaeval pictures was a trick, as oil-painting itself was a trick when first used. Constant renewal of technique is one of the principal means by which an artist escapes the prison of his own style, as much a necessity as escape from the prison of another's style.'

Some years later Picabia reworked the whole image. He pulled off all the collaged elements except the measuring tape, exposing in the process areas of bare canvas. He then painted the man's features in black, replicating the shapes of the original collaged elements, and stuck on new, larger combs in the area of the man's hair. Most dramatically, he painted in outline over the man's face the head and hands of a glamorous woman, with blue eyes and full red lips. Such overlapping of different images was a feature of Picabia's 'Transparency' paintings, the first of which date from the late 1920s. This technique allowed Picabia to create complex works, evocative at times of dream-like states of mind. In the case of *The Handsome Pork-Butcher* (the title the work had when it was exhibited in early 1949), the two images of the man and the woman occupy the same space but nonetheless remain separate and incongruous. It is known that this process of repainting was completed by 1935: a photograph of Picabia's studio, taken in the summer of that year, shows the work in its revised form with the original Legrain frame (now lost).

With its layering of different images and combination of styles, *The Handsome Pork-Butcher* resists straightforward interpretation. This denial of conventional ways of understanding images was central to the work of this pioneer of the Dada movement and is evidence of his determination to constantly reinvent himself. William Camfield, who has written extensively on Picabia, has commented that Picabia's decision to repaint the original 1920s work bears witness to the artist's 'constant and sometimes dumbfounding self-liberation from the past'.

JM

Oil, string, measuring tape and combs on canvas
92.5 × 73.7 (36³/₈ × 29)

Provenance
… Galerie Van Leer, Paris, when reproduced in *Artwork*, London, Jan. 1928;
… E.J. Power before March 1964, when exhibited in *Francis Picabia*, Hatton Gallery, Newcastle, and Institute of Contemporary Arts, London, March–April 1964 (25)

Accepted by the Commissioners of Inland Revenue in lieu of tax and allocated 1996

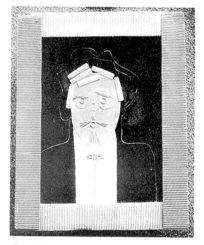

fig.10 Reproduction in *Artwork*, London 1928, p.248

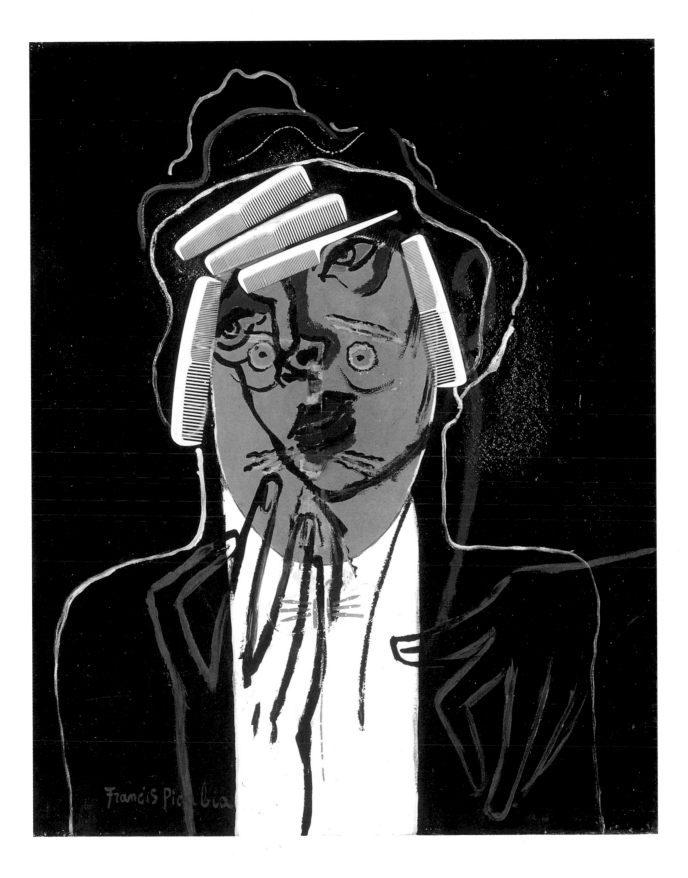

JEAN DUBUFFET
1901–1985

Large Black Landscape 1946
Grand Paysage noir

Dubuffet's career as an artist began in war-torn Paris in 1942 when he was forty-one. Twice before he had attempted to make a career as an artist but, dissatisfied with the academic nature of his paintings, he had settled instead for running the family wine business. This time he was determined to paint for his own pleasure and remain true to his 'anti-cultural' beliefs. Along with such artists as Fautrier, Wols and Chaissac and such writers as Artaud, Paulhan and Bataille, Dubuffet became passionately interested in the art of ordinary people, children and the mentally ill. He believed that such art, which he called *Art brut*, was free from the taint of the cultural conventions governing fine art and reflected the true dynamics of the human mind. He declared himself an artist of the people: in a lecture given in 1951 he said that he aimed to produce 'an art that is directly plugged into our current life, that immediately emanates from our real life and our real moods'.

Large Black Landscape is the culminating work of a series of landscapes executed between July and September 1946. Its black surface, built up of layers of paint into which lines have been scraped and gouged, is reminiscent of an aged and crumbling, graffiti-covered wall. It is hard to decipher the painting's linear markings, many of which appear non-representational. However, the image, which appears to be both a cross-section of the scene and a view across the terrain, includes paths leading up to the high horizon, houses, trees and two children. In the sky is a pallid, sickly coloured sun and a sign resembling a clutch of balloons but used by Dubuffet to represent a 'dancing cloud'.

Towards the end of the war Dubuffet had produced several paintings and lithographs featuring graffiti or messages scrawled on walls. Among these were two illustrations – one of grafitti, the other of two men urinating against a wall – for a book of poetry by his friend Eugène Guillevic entitled *The Walls*. Mildred Glimcher, author of a recent monograph on the artist, wrote that this volume 'united his excitement with the life of the street, the sense of adventure he and his friends felt when confronted with the hand of ordinary men – the graffiti on walls with their time-worn patina – and (like the *Art Brut* artists) the combining of writing and images'.

For the critic Lawrence Alloway, writing in 1958, the striking feature of *Large Black Landscape*, then known as *Façade-Landscape*, was that Dubuffet had 'humanised' the flat picture plane associated with modernist painting. In the catalogue for the exhibition *Some Paintings from the E.J. Power Collection*, held at the Institute of Contemporary Arts, London, in 1958, Alloway noted: 'He [Dubuffet] creates a thick hide of paint which he then scratches, finding colour underground – like a miner, making signs – like anybody writing on a wall. Thus, the flat surface is as "real" as a wall covered with graphic signs and traces of human activities. Flatness becomes the most natural way of organising the picture and not, as in much early modern art, a way of compressing the world into an esthetic sandwich.'

JM

Oil on board
154.9 × 116.8 (61 × 46)

Provenance
… Sidney Janis Gallery, New York, by whom sold to Martin Janis (date unknown); repurchased by Sidney Janis Gallery, New York (date unknown); sold to Arthur Tooth & Sons Ltd, London, Jan. 1958, from whom purchased by E.J. Power Jan. 1958

Accepted by the Commissioners of Inland Revenue in lieu of tax and allocated 1996

JEAN DUBUFFET
1901–1985

Monsieur Plume with Creases in his Trousers (Portrait of Henri Michaux) 1947
Monsieur Plume plis au pantalon (Portrait d'Henri Michaux)

In October 1947 Dubuffet exhibited a series of over seventy portrait paintings and drawings at the Galerie René Drouin, Paris. In the accompanying catalogue he declared, 'People are more handsome than they think. Long live their true faces'. As if to explain how his portraits differed from conventional likenesses, he went on to describe them as having been 'extracted' from his memory, where they had been 'cooked and preserved', and also 'exploded'. The subjects of the portraits were all friends of Dubuffet: artists, critics and writers, among whom were some of the best-known literary figures of the day. Henri Michaux was a writer and an artist, who had published in 1930 and 1938 texts describing the semi-comic adventures of a man named Plume. It is possible that this character was in some sense a self-portrait, an identification that Dubuffet seems to have seized upon in titling his portrait of the writer 'Monsieur Plume'. Many of Dubuffet's portraits had allusive or humorous titles: *Limbour Fashioned from Chicken Droppings*, *Limbour as a Crustacean*, and *Maast with a Mane (Portrait of Jean Paulhan)* were typical. Offering at best only a caricatural resemblance to their subjects, the portraits called into question the codes governing traditional portraiture.

The 1947 exhibition caused a minor sensation: the gallery employed an armed guard at the door in case of disturbance, and dozens of articles appeared in the newspapers as well as in the more specialised art and literary magazines. Predictably, many reviewers dismissed the works as crude or as products of the unsettled and anxious times ('all these large and heavy faces, under which are placed the names of our contemporaries, express more scorn than love for mankind'). Some admired Dubuffet's use of non-traditional materials. Others questioned why he had chosen to paint portraits at all.

The catalyst for the series seems to have been Florence Gould, an American expatriate collector, literary patron and host of regular lunch parties for writers and artists. It was she, it appears, who urged Dubuffet to paint some of those in her circle. Inspired by this idea, Dubuffet executed more than one hundred and fifty portraits of twenty-two sitters between August 1946 and August 1947. Many of the sitters were friends and associates of Jean Paulhan, a key figure in the intellectual debates of the time and an early supporter of Dubuffet's work. In this period Paulhan, despite his credentials as a noted *résistant*, led the opposition to the contemporary blacklisting of writers deemed to have collaborated in some way with the German occupation. Dubuffet seems to have shared Paulhan's reservations about the post-war purges of so-called collaborators, and included in the series of portraits some who were blacklisted by the National Writers' Committee.

In this series of portraits Dubuffet seems to have delighted in subverting portraiture's traditional celebration of the individual. His images resemble crude effigies, their lines gouged into layers of thick paint. In his catalogue essay for the 1947 exhibition Dubuffet wrote that identity was only revealed at the very margins of definition: 'In order for a portrait to work for me, I need it to be hardly a portrait. At the limit where it is no longer a portrait, it's there that it functions with its greatest force.' He added, in 1953, 'Those who have spoken about my portraits as an undertaking aimed at psychological penetration have understood nothing at all. These portraits were anti-psychological, anti-individualistic'. Dubuffet's interest in the genre of portraiture seems to have exhausted itself with this series, and the figures that appear in his later works, even when they bear the names of real persons, are no more than generalised and interchangeable images.

JM

Oil and grit on canvas
130.2 × 96.5 (51¼ × 38)

Provenance
… Michel Tapié, Paris; with Galerie Rive Droite, Paris, through whom purchased by E.J. Power 1957

Purchased from E.J. Power 1980

JEAN DUBUFFET
1901–1985

The Tree of Fluids 1950
L'Arbre de fluides

In April 1950 Jean Dubuffet embarked on a series of paintings entitled *Corps de dames* or 'ladies' bodies'. The distortion of the female body in these paintings – it appeared as if flattened by a steamroller, with sexual parts laid bare – has led some commentators to compare Dubuffet's works to the contemporaneous series of *Woman* paintings by the Dutch-American artist Willem de Kooning. However, the grotesqueness of Dubuffet's images is often countered by the smiling insouciance of the figures. Furthermore, the marked parallels beween the women's bodies and the natural landscape can be seen as celebratory of women's fertility. The writer and Dubuffet's close friend Georges Limbour wrote in 1958, 'the famous *Corps de Dames* seemed monstruous to those who wanted to reduce them to what they were only in part – women. The texture of these bodies shows clearly that they are not big hunks of flesh, but rather terrestial slime, the substance of mountains and moors'.

The Tree of Fluids was first exhibited at the Pierre Matisse Gallery, New York, in 1952. In the catalogue text Dubuffet described how, using zinc oxide and a 'lean but viscous' varnish, he had developed a special paste which repelled oil paint and created fantastic and unpredictable effects:

> This paste, while still fresh, repels the oil, and the glazes one applies on it organise themselves into enigmatic branchings. Gradually, as it dries, its resistance to the fat coloured sauces weakens, and it assembles them differently. Its behavior changes every fifteen minutes … These branched facts, running trees, by which I saw my figures illuminated, have transported me into an invisible world of fluids circulating in the bodies and around them, and have revealed to me a whole active theatre of facts, which perform, I am certain, at some level of life. (original translation)

In the same passage Dubuffet mentioned *The Tree of Fluids* as a prime example of the application of his new technique to the female nude (or, to use his non-technical term, 'ladies' bodies'). This subject had dominated his work for the previous year and more. Explaining why he had become interested in this genre, 'so typical of the worst painting', he wrote:

> the female body, of all the objects in the world, is the one that has long been associated (for Occidentals) with a very specious notion of beauty (inherited from the Greeks and cultivated by the magazine covers); now it pleases me to protest against this aesthetics [sic], which I find miserable and most depressing. Surely I aim for a beauty, but not that one … The beauty for which I aim needs little to appear – unbelievably little. Any place – the most destitute – is good enough for it. I would like people to look at my work as an enterprise for the rehabilitation of scorned values, and, in any case, make no mistake, a work of ardent celebration.

JM

Oil on canvas
115.6 × 88.9 (45½ × 35)

Provenance
Purchased from the artist by Pierre Matisse Gallery, New York, April 1951; bought by William A. Rubin, New York, March 1958, by whom sold to Jacques Sarlie, New York, c.1961; … E.J. Power

Accepted by the Commissioners of Inland Revenue in lieu of tax and allocated 1996

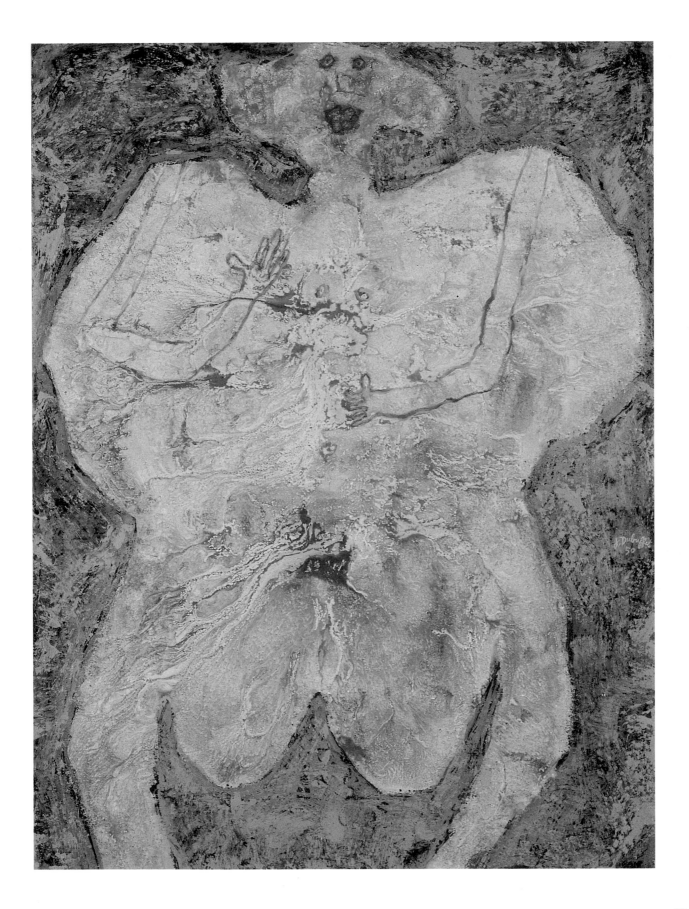

33

NICOLAS DE STAËL
1914–1955

Composition 1950
Composition

Oil on board
124.8 × 79.4 (49⅛ × 31⅛)

Provenance
With Jacques Dubourg, Paris; with Mayor Gallery, London, from whom purchased by E.J. Power 1956

Purchased from E.J. Power 1980

Nicolas de Staël used the nondescriptive title *Composition* for many paintings of this period. For him, it was a way of signalling not so much that the images were nonrepresentational but that they had been literally 'composed', using areas or blocks of carefully modulated colour to create the impression of light, space and movement.

His approach to painting was largely intuitive. In a letter of 1945 he wrote: 'I have confidence in myself only because I have confidence in no one else, and in any case, I cannot know myself what a painting is or isn't, or establish new precepts, before actually painting. One must work constantly – with a ton of passion and a few ounces of patience'. Suspicious of theories of painting, he did not define himself as an abstract painter, and made no secret of his lack of regard for the work of some of his contemporaries, in particular, the abstract lyricism of Hartung, Schneider and Soulages, and the *tachisme* of Wols and Mathieu. Rather than expressing the mood of the times, he saw his work as addressing the perennial problems of artistic creation. It was no accident that his closest artist friend in these years was Georges Braque, whose works, with their highly structured compositions and sublimated emotions, epitomised the classical French tradition in art.

De Staël had known many years of poverty, both before and after his adoption of a nonfigurative way of painting in 1942. However, his material circumstances gradually improved in the post-war years. Such dealers as Louis Carré and Jacques Dubourg became interested in his work, and by 1948 he was identified by some critics as one of the most talented of the emergent generation of abstract artists. Roger van Gindertaël, for example, wrote, 'I do not think I risk too much in claiming that the work of Nicolas de Staël is the most important new discovery in the art of today since Picasso, and one of the things determining the "raison d'être" of contemporary painting'. His paintings were acquired by the Phillips Collection, Washington, in 1949, and by the Musée national d'art moderne, Paris, in 1950.

By this point de Staël had abandoned the tangled bars and dark, constricted space that had marked his works of 1946–8. Instead, he now created his compositions using simplified but still irregular shapes, each one treated as a flat area with a distinctive, though not necessarily a pure, tonality. Employing a palette knife, he built up smooth layers of thick paint, in the interstices of which could be glimpsed the colours of the underlying layers. *Composition* is an example of de Staël's masterly use of subtle shades of grey to create a sense of light and space. (In 1953 the critic Pierre Lecuire wrote of de Staël's use of grey: 'There would be no light in this painting, no atmosphere, no transparency, the eye would be buried in cement, no air would circulate, there would be no possibility of happiness without these famous greys. These greys are unique in all contemporary painting.') Although there are no obvious allusions to known forms in this work, the colours and the shapes were based on the artist's perceptual experience of reality. In his 1961 monograph Denys Sutton wrote, 'De Staël ... never doubted that it was his duty as a painter to try and reconcile the pattern of abstract forms and arbitrary colours, which are the constituent elements of a painter's language, with the facts of a visual and emotional experience'.

JM

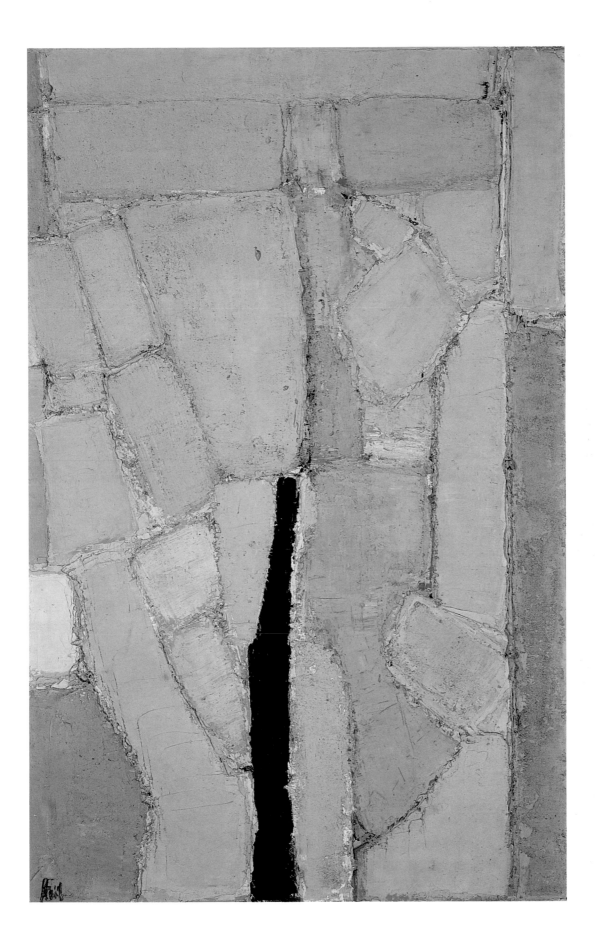

BARNETT NEWMAN
1905–1970

Eve 1950

Eve consists of a field of colour painted entirely in cadmium orange apart from a narrow, dark crimson band painted vertically along the right edge from top to bottom. Newman has signed the painting in the bottom right-hand corner of the cadmium orange field, thereby disrupting its evenness. In every other respect, however, the field is unmodulated.

Eve and its companion *Adam*, also in the Tate's collection, were the last two paintings Newman completed before his second one-man show at Betty Parsons Gallery, New York, in 1951. At that time *Adam* had only two stripes (it now has three). The compositional similarity between the two paintings, however, is no more marked than between *Eve* and a large number of other paintings by Newman of this period. It was in any case Newman's practice to title his paintings with words which referred to the Old Testament.

In the mid-1940s Newman had made a number of paintings on the theme of creation. These consisted of biomorphic images evoking the birth of the world, form, and light. He was acutely aware that American art stood on the verge of a breakthrough and argued that it could not simply continue to emulate European models which were steeped in the Renaissance tradition. Thus, he rejected the example of Picasso as much as that of Miró. Similarly, he rejected the examples of what he considered to be pure abstraction found in the works of Mondrian and Malevich. Looking back on this period, Newman stated, 'we actually began, so to speak, from scratch, as if painting were not only dead but had never been executed'. At the same time he sought a kind of painting which, if it abandoned the subject in the conventional sense of the depicted image, sought the subject in terms of something to communicate. Newman wrote of painting in this period: 'We are making it out of ourselves, out of our own feelings. The image we produce is the self-evident one of revelation, real and concrete, that can be understood by anyone who will look at it without the nostalgic glasses of history.'

In 1948 Newman made a breakthrough in painting *Onement I* (Museum of Modern Art, New York), a small canvas in which an earthy brown field is divided in two by a vertical red stripe. In this and other paintings, the stripe, known as a 'zip', symbolises the act of creation, forming an image by dividing the colour field. The 'zip' can be likened to God's primal gesture, the creation of light and dark, the division into two, which, by extension, represents the creation of Adam and Eve.

Newman, like other American artists of this period, was interested in the notions of tragedy, the sublime and transcendence. 'Shall we artists', he wrote in 1948, 'make the same error as the Greek sculptors and play with an art of overrefinement, an art of quality, of sensibility, of beauty? Let us rather, like the Greek writers, tear the tragedy to shreds.' Analysing the situation in 1948 he stated: 'We are living … through a Greek drama; and each of us stands like Oedipus and can by his acts or lack of action, in innocence, kill his father and desecrate his mother.' The terror of humanity was, in his view, now known and was therefore no longer terrifying but tragic, for terror lies before the unknown. The task for the artist was to communicate this tragedy by transcending the outward appearance of forms and grasping the essence.

JL

Oil on canvas
238.8 × 172.1 (94 × 67³/₄)

Provenance
Purchased from the artist through David Gibbs, London, by E.J. Power 1959

Purchased from E.J. Power 1980

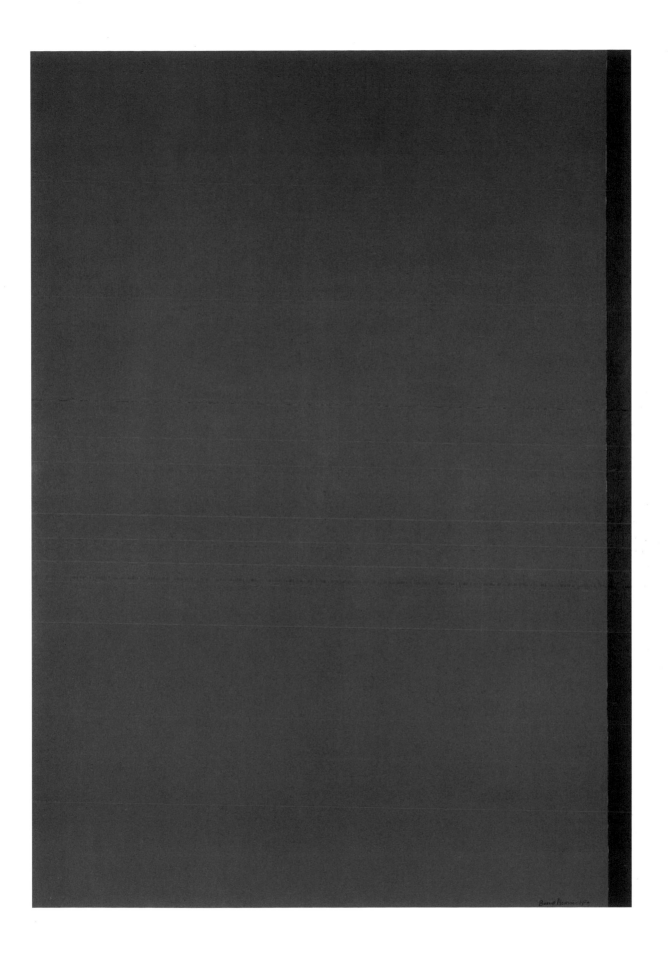

RICHARD HAMILTON
born 1922

Hommage à Chrysler Corp. 1957

Established at the Institute of Contemporary Arts, London, in 1952, the Independent Group, in which Richard Hamilton was a central participant, was a key forum for the emergence of ideas that were to transform the map of British art. Reacting against prevailing concerns with Neo-Romanticism, realism and abstraction, the Group studied the sophisticated techniques of American mass-media imagery and admired its style, its flair and its richness on the level of imagination. *Hommage à Chrysler Corp.* represents the emergence of these preoccupations into the art of painting and is a work of particular importance in the formulation of the Pop aesthetic.

The most dramatic public incursion of Pop into the consciousness of the art community was the walk-in stand contributed by Hamilton, John McHale and John Voelcker to the exhibition *This Is Tomorrow* at the Whitechapel Art Gallery in 1956. Prominent among that environment's concerns were looming modern machines, sex symbols and spatial ambiguity. Hamilton carried all of these directly into *Hommage à Chrysler Corp.*

After *This Is Tomorrow*, Hamilton realised that the aesthetic he and his colleagues were celebrating called for definition, and in a well-known letter of January 1957 he described Pop art as 'Popular (designed for a mass audience), Transient (short-term solution), Expendable (easily forgotten), Low Cost, Mass produced, Young (aimed at youth), Witty, Sexy, Gimmicky, Glamorous and Big business'. In formulating this definition Hamilton, in line with the Independent Group's thinking, had in mind not fine art but that part of contemporary culture in which skilled professionals made products for a mass market. He immediately began, however, to paint *Hommage à Chrysler Corp.*, and, in so doing, programmatically to introduce the majority of the attributes of Pop, as he had defined it, into fine art. As Hamilton was to write in 1961: 'If the artist is not to lose much of his ancient purpose he may have to plunder the popular arts to recover the imagery which is his rightful inheritance.'

Hamilton conceived the picture's setting as a motor showroom in the International Modern style (as the depth-creating bar at top right denotes). In this work Hamilton extended the investigation of the relationship between humans and machines that had been the subject of his remarkable exhibition *Man, Machine and Motion* in 1955. Here, however, the focus is on a notable topic of Independent Group discussions, the styling of large and gleaming American cars and the conventions of their promotion in advertising.

Many of Hamilton's works have titles which are *double entendres*. In this picture the homage is being paid not only to the giant American car-manufacturing corporation named in the title but also to the *corps* (body) of a car. Prominent, too (at centre-image), is the body of a woman, caressing the car and identifiable by the floating lips of American television star Voluptua. Hamilton wrote, 'My sex symbol is, as so often happens in the ads, engaged in a display of affection for the vehicle', and that the 'dreamboat' joins the 'dream car'.

In its employment of mixed media, in its precision and painterly delicacy and in drawing an analogy between the functions and components of a machine and the physiological processes and erotic drives of the female body, *Hommage à Chrysler Corp.* can also be read as a homage to the French Dada artist Marcel Duchamp. It was painted in the year in which Hamilton began work on his typographic version of Duchamp's *Green Box*, ninety-three fragments of text which both underly and comment on the latter's masterpiece, *The Large Glass*, 1915–23 (which, following the shattering of the original in 1926, Hamilton was to reconstruct in 1965–6).

RM

Oil, metal foil and collage on wood
122 × 81 (48 × 31⁷/₈)

Provenance
Purchased from the artist by E.J. Power 1963; E.J. Power estate 1993, from which purchased through Waddington Galleries, London, 1995

Purchased with assistance from the National Art Collections Fund and the Friends of the Tate Gallery 1995

fig.10 Marcel Duchamp and Richard Hamilton, *The Bride Stripped Bare by her Bachelors, Even* 1915–23, replica 1965–6, oil, lead, dust and varnish on glass, 277.5 × 175.9 cm. Tate Gallery

ELLSWORTH KELLY
born 1923

Broadway 1958

Broadway is a red square painted on top of a white rectangular ground. The red square is slanted on a diagonal axis as though it were a face of an isometric projection of a cube. The paint is applied evenly and the surface has a neutral, impersonal quality. The way in which the red square is offset against the white rectangle stresses the frontal nature of the painting. It also introduces an element of perspective and suggests the extension of the colour beyond the confines of the painting. The presence of the white ground along the vertical edges of the red square accentuates the edges of the red.

Kelly was born in New York State in 1923 and studied at the Pratt Institute, Brooklyn, and the Boston Museum School. After the war he spent six years in Paris, returning to New York in 1954. The years in Paris were particularly important, for it was there that Kelly met the principal members of the European avant-garde interested in abstraction, among them Jean Arp, Sophie Taeuber-Arp, Georges Vantongerloo and Brancusi, whose studio he visited in 1951. After beginning as a figurative artist, Kelly soon changed direction and devoted himself to abstraction, albeit based on the perception of things in the real world – architecture, urban environment, plants and landscape and, generally, the effects of light and shadow.

Broadway was painted four years after he returned from Paris to New York and belongs to a series of works based on urban places in New York. The titles of the other canvases, all painted in 1958, are *Brooklyn Bridge*, *Manhattan* and *Wall*. The works were all shown together at Kelly's exhibition at the Galerie Maeght, Paris, from where E.J. Power purchased *Broadway*. In 1956 Kelly had made a smaller version of this painting in black and white, which became, in effect, a study for *Wall*. 'My original intention', he wrote, 'was to paint a larger black-and-white *Wall*, but it came out red; and after *Broadway* was completed, I still wanted the black, so in July 1958 I painted *Wall*.' Kelly often painted differently coloured versions of paintings in this period, black often being the first version. While the paintings he had executed in his Paris years were often multi-coloured, Kelly now used colour singly, as a sensual element within a white field, which acted as a neutral container and not as a contrasting element. Thus, the red form, in spite of its flatness, has a certain sculptural quality. Kelly later explored this quality in such freestanding sculptures as *Curve XXXI*, 1982 (Tate Gallery).

The title *Broadway* refers to the street in New York City famous for its theatres and symbolic of American showbiz culture. But Kelly has said that he also chose the title because the name implied space or 'broad way'. It is possible that the diagonal thrust of the red square refers to the diagonal path of Broadway through Manhattan. A number of Kelly's paintings of this period act as generalised reminders of the urban environment – of billboards, signs, posters and large surfaces. As the artist John Coplans has written: 'His abstract images are presented with great clarity and simplicity; their scale and shape catch the eye and, like city signboards, they aggressively capture the viewer's attention. In this sense, Kelly's art ... is not intimate. It is ... public, provocative in scale and size, and therefore related to the cityscape in its intensity and visual power.'

JL

Oil on canvas
198 × 177 (78 × 69½)

Provenance
Purchased from Galerie Maeght, Paris, through Arthur Tooth & Sons Ltd, London, by E.J. Power Nov. 1958

Presented by E.J. Power through the Friends of the Tate Gallery 1962

ALAN DAVIE born 1920
Image of the Fish God No.7 1956

Oil on board 153 × 121.9 (60¼ × 48)

Purchased from the artist through Gimpel Fils, London,
by E.J. Power 1957
Presented by E.J. Power through the Friends of the Tate Gallery
1973

This painting is one of a group of seven with the same title,
all painted in 1956. Each work is of the same dimensions,
although three have a horizontal rather than vertical format.
The basic compositional elements are similar in each, with the
two-pointed right-angled shape, the central diamond and the
dark humanoid shape appearing in approximately the same
configuration. Although the title seems to support a reading
of the dark shape as a figure, it was not the artist's particular
wish to encourage this. Characteristically, Davie has referred to
this title as a 'poetic interpretation', rather than a literal
description, of the image. For him, painting was not so much
a means of expression as a medium through which to experi-
ence the inner self, both for practitioner and for viewer. In an
approach which shared much with Zen Buddhism, which he
discovered in 1955, Davie sought to reach spiritual illumina-
tion through painting. He has described the forms which he
used as 'primordial symbols' with no conscious or quantifi-
able significance, but which could carry a multiplicity of
meanings.

Davie did not paint the *Image of the Fish God* works as a series
but more as a unit, working on all or several of them simul-
taneously. He described them as having developed together 'in
a quite miraculous way'.

MP

BERNARD COHEN born 1933
Early Mutation Green No.II 1960

Oil and housepaint on canvas 183.5 × 213.4 (72¼ × 84)

Purchased from Gimpel Fils, London, by E.J. Power
1960
Presented by E.J. Power through the Friends of the Tate Gallery
1962

This painting consists largely of an image of pronounced for-
mal clarity, but a crucial element is the irregular blue 'flash'.
This thwarts a confident reading of the whole and also disrupts
the mood of mysterious solemnity the picture would other-
wise convey. Cohen has long believed that immaculate struc-
tures lack an essential reality, and that truth lies in the fusion of
the rational with the irrational. Each of his paintings charac-
teristically establishes a pictorial system only to subvert it by
acts of deliberate absurdity. The process is analogous to that of
the conflict between the weight of tradition and authority and
the resulting need for freedom and development.

In contrast to the instinctive gestural painting that was dom-
inant in the late 1950s, Cohen emphasised the contrivance cen-
tral to the process of making art. He saw the essence of painting
as lying in decision-making rather than in lyricism. As was
affirmed in 1960 by the important exhibition *Situation* (in
which Cohen showed), a large expanse of canvas made the
deployment of marks upon it no less of an 'event' when these
were broadly formal in nature or undirected towards the evo-
cation of pictorial space. The repetition here of concentric cir-
cles counters a mystical or cosmic reading of the motif. Like the
rectilinear arch form, they are experienced more as 'given'
shapes, with something of the familiarity of modern city life.
The scheme's invasion by the blue flash directs attention at once
to the picture's surface and to the acts the artist has performed.

RM

PETER STROUD born 1921
Six Thin Reds 1960

Plastic emulsion paint on hardboard with wooden strips in relief
213.4 × 134 × 1.9 (84 × 52³/₄ × ³/₄)

Purchased from the artist by E.J. Power 1960
Presented by E.J. Power through the Friends of the Tate Gallery
1962

Stroud made constructivist works using Perspex, aluminium
and copper until 1958 when he decided that the intrinsic
qualities of these materials were too restrictive. In particular,
he thought that their reflective surfaces distanced the viewer
from the work of art. He therefore turned to a technique
which he named 'relief-painting', in which he attached raised
strips of painted wood to coloured grounds. He described
how, by introducing this element of relief into painting, 'a
common space is established where the viewer's life, space
and the aesthetic of the art work become one'. Stroud reject-
ed the multiple viewpoints typical of constructivist works and
came to rely heavily on symmetry in his work. *Six Thin Reds* was
his first strictly symmetrical relief-painting. However, he also
considered it an inherent part of the work that the raised
wooden strips disrupt the symmetry of the composition
when viewed from one side. This introduced the tension
between two-dimensional illusion and three-dimensional
reality, and between symmetry and asymmetry, which he
believed was necessary in order to heighten the viewer's
awareness of being physically in the same space as the work
of art itself.

MP

PETER BLAKE born 1932
Tuesday 1961

Enamel paint, wood relief and collage on hardboard
47.6 × 26.7 × 3.8 (18³/₄ × 10¹/₂ × 1¹/₂)

Purchased from Arthur Tooth & Sons Ltd, London, by
E.J. Power April 1962
Presented by E.J. Power through the Friends of the Tate Gallery 1974

This picture is named after Tuesday Weld, a young screen
actress who, like Lee Remick, Christine Kaufmann and Carroll
Baker, began her career in the early 1960s and became one of
the sex symbols of the day. Blake selected her as the subject of
this painting because of her unusual first name. Two pho-
tographs of Weld are included at the top of the painting. In
one she wears a fur-lined hood. The other shows her in bed.
Below the two pictures, the word 'Tuesday' is picked out in
plastic letters affixed to the hardboard support. An upturned
'V' stands in for the missing 'A'. Underneath, three bands of
bright, undifferentiated colour recall the hard edge abstract
painting then at the forefront of contemporary art.

The relation between different registers – 'high art' abstrac-
tion on the one hand and 'mass market' magazine illustrations
or postcards on the other – was explored by Blake in several
other similarly structured paintings of the time. These include
the closely related *Kim Novak Wall* (private collection) and *The
Fine Art Bit* (Tate Gallery), both made in 1959. The use of plas-
tic letters relates *Tuesday* to other, more elaborately constructed
collaged reliefs such as *Love Wall* (Fundação Calouste Gul-
benkian), *The First Real Target* (Tate Gallery), both 1961, and *The
Toy Shop*, 1962 (Tate Gallery). These paintings include real
objects, a practice which extends Blake's established concern
with British popular culture while demonstrating an aware-
ness of the work of American artists such as Jasper Johns.

SR

R.B. KITAJ
born 1932

The Murder of Rosa Luxemburg 1960

This work was made while Kitaj was a student at the Royal College of Art, London. An American, he had come to England on the G.I. Bill. Already Kitaj's own interests and life experiences were at the centre of his vision as a painter. Each work transmitted its own distinct atmosphere and seemed charged with psychological urgency.

The Murder of Rosa Luxemburg is an early example of Kitaj's many paintings on the theme of the unjust infliction of human suffering. In particular, it manifests Kitaj's awareness of his own Jewish identity and his anger at persecution of the Jewish people. These inseparable strands form a continuous thread through Kitaj's mature work.

The theoretician and agitator Rosa Luxemburg (born 1871), who was Jewish, was one of the founders of the German Communist Party. In 1919 she was murdered by troops opposed to the German revolution. Luxemburg's death occurred roughly midway between the emigrations, on account of deadly threats to the Jewish population, of two of Kitaj's grandmothers, each of whom is represented here in a different way.

The veiled figure at top left is Kitaj's maternal grandmother, who left Russia. In front of her a figure, identified by the artist as a young man, holds Rosa's battered corpse. But Kitaj here associates Luxemburg with Helene Kitaj (mother of the stepfather whose surname Kitaj took), who fled Vienna in the 1930s. He has written that: 'Grandmother Helene … prefigures Rosa L. (in my life). Helene and Rosa L. looked alike, dressed alike (the long black dress and boots in the picture were worn by Helene …), and … were both from that highly cultivated middle class of emancipated Central European Jews, which has, in its brilliance and its disaster, written its own legend by now, or history has done.' He has also observed that Helene's two sisters were murdered by the Nazis in the same camps as were three of those of the novelist Franz Kafka, to whom, 'I feel closer than to any other … Above all, Kafka encourages me to know myself and to puzzle out my own Jewishness and to try to make that over into an art of picture-making'.

Both in finding sources for his pictures and in making their images, Kitaj's methods were highly unorthodox and influenced his younger fellow students. The outwardly illogical juxtapositions in his paintings, whether of styles, of motifs or of relative scales, were a legacy both of the poetry of Ezra Pound and T.S. Eliot and of the Surrealist practice of free association. Particularly original was the sense that Kitaj's art merged the practices of both studio and library. Here, a key influence on him was the discipline of iconography (the study of the meaning of images), above all through the work and publications of the Warburg Institute. Significantly, the Institute had moved to London in 1933 to escape Nazi persecution.

The collaged elements in this painting include a text at top right, meticulously handwritten by Kitaj. This transcribes a shocking account of Rosa Luxemburg's murder. It also helps to identify several of the work's images. The standing figure at the top recalls the statue which surmounts the monument commemorating the foundation of the new German Empire in 1871. The head with a peaked hat resembles that of Field-Marshal Count von Moltke, while the image at bottom left (based on one Kitaj found in the *Journal of the Warburg Institute*) recalls a monument to Frederick the Great and his Generals. Kitaj has observed that the coloured structure towards top left 'prefigures certain pyramidal monuments deliberately created in some Jewish cemeteries in eastern Europe after the war out of fragments of gravestones'.

RM

Oil and collage on canvas
153 × 152.4 (60¼ × 60)

Provenance
Purchased from Arthur Tooth & Sons Ltd, London, by E.J. Power Oct. 1961

Purchased from E.J. Power 1980

CLAES OLDENBURG
born 1929

Counter and Plates with Potato and Ham 1961

Counter and Plates with Potato and Ham is a sculpture in painted plaster which represents a counter of a restaurant on which are a sandwich cut in half, a portion of potato, French bread, and slices of ham. The starting point for the sculpture was a restaurant in the neighbourhood of The Store, Oldenburg's studio of the early 1960s. The Store was situated on the lower East Side of Manhattan at 107 East 2nd Street. Although the items of food are painted with some degree of naturalism, the counter is painted green and blue, colours which Oldenburg described as related to landscape. The surface of the counter is rough and uneven, as are its edges.

The objects which Oldenburg made, and which are known collectively as The Store, were first shown in part at Martha Jackson Gallery, New York, in 1961. They were then realised in full in Oldenburg's storefront studio. All the objects, which were made from muslin dipped in plaster and stretched over chicken wire and painted, were inspired by food, clothing, objects available in neighbourhood shops, and advertisements. They are deliberately vulgar and rough but also highly sensuous. Oldenburg was well aware that clothes and food could be the source of erotic obsession and sensual fulfilment. In 1968 he wrote: 'The Store is born in contorted drawings of the female figure and in female underwear and legs, dreams of the proletarian venus, stifled yearnings which transmute into objects, brilliant colors and grossly sensuous surfaces.' The plaster thus becomes skin, the container for the body within. The organic nature of Oldenburg's sculpture in this period anticipates his subsequent development of soft sculptures in which everyday objects, normally perceived as having rigid shapes, were represented as collapsed, organic soft forms. Oldenburg's interest in this area parallels that of Eva Hesse, whose abstract sculptures of the 1960s also have erotic, organic overtones.

The Store was both a shop for selling Oldenburg's art and a parody of a shop, just as the sculptures were objects and depictions of objects as well as parodies of objects. They were, furthermore, ironic comments on the gestural art of the Abstract Expressionists, for the paint is applied in splashes and drips. Acknowledging the relationship of his work to Abstract Expressionism, Oldenburg stated: 'I feel as if Pollock is sitting on my shoulder, or rather crouching in my pants.' Like Pollock, he employed enamel paint. However, as well as parodying the work of the previous generation, Oldenburg rebelled against it. In 1961 he wrote: 'My struggle has been to return painting to the tangible object, which is like returning the personality to touching and feeling the world around it, to offset the tendency to vagueness and abstraction.' Oldenburg was interested in demystification, in making art which 'grows up not knowing it is art at all, an art given the chance of having a starting point of zero'. 'I am for an art that takes its forms from the lines of life itself, that twists and extends and accumulates and spits and drips, and is heavy and coarse and blunt and sweet and stupid as life itself.' Banality was thus an important element, as it was in the work of his contemporaries Jasper Johns, Robert Rauschenberg and Roy Lichtenstein.

This sculpture was one of the first of those made for The Store.

JL

Painted plaster on wire netting in three parts
overall dimensions 11.7 × 107.3 × 57.8 (4⅝ × 42¼ × 22¾)
two small elements 0.5 × 20 × 13.5 (¼ × 7⅞ × 5¼); 1.5 × 20.5 × 13.5 (½ × 8⅛ × 5⅜)

Provenance
…; purchased from Mr Robert Kleiner, Beverly Hills, through Richard Feigen Gallery, New York, by E.J. Power April 1964

Presented by E.J. Power through the Friends of the Tate Gallery 1970

ALLEN JONES
born 1937

The Battle of Hastings 1961–2

In 1959–60 Allen Jones studied at the Royal College of Art, where his fellow students included Derek Boshier, Patrick Caulfield, David Hockney, R.B. Kitaj and Peter Phillips. With these painters, he was one of a generation of Pop artists linked with the Royal College of Art, who spearheaded the development of some important developments in figurative painting in Britain during the 1960s. Even so, as *The Battle of Hastings* reveals, there is in Jones's early work evidence of his interest in aspects of two apparently opposed modes of expression: figuration and abstraction. The dilemma of choosing between these tendencies was then being debated in artistic circles, and in a number of respects the painting can be seen as marrying the two.

The Battle of Hastings comprises a square expanse of canvas within which are situated various elements – figurative, heraldic and abstract – disposed unevenly within the picture space. The way these different elements interrelate and connect, almost in a continuous flow, suggests Jones's interest in automatism, derived from Surrealism and Abstract Expressionism. Indeed, at the time this painting was completed, it was Jones's practice to work from small, rapidly improvised preparatory sketches. Moreover, during the execution of the paintings, the image would often evolve freely and independently in response to marks and gestures made during the process of painting.

From 1960 to 1961 Jones attended a teachers' training course at Hornsey School of Art. The source for *The Battle of Hastings* was a diagram which he made for a group of eleven-year-old pupils in a lesson he gave during his teaching practice on this course. In the lesson in question, Jones explained the strategies of the forces involved in the Battle of Hastings of 1066, in which King Harold II of England was defeated by Duke William of Normandy. During that decisive engagement Harold was struck in the eye by an arrow and died. The drawing evolved as a way of indicating the landscape and the positions of the opposing armies. Jones recalls that subsequently he 'happened to look at the board in a more objective moment and I realised that it was a hell of a little diagram. So the painting really records the path of the arrow and also the path someone would take in falling over'.

The resulting painting is complex. Ostensibly, its subject is a historical event, and a narrative is implied in the inclusion of tiny figures and flags. In the way it derives from a map the painting can also be seen as kind of landscape – a genre unusual in Jones's work. However, his treatment of these themes is non-literal, eclectic and contradictory. One of his main concerns is the idea of trajectory. This notion, its connection with arrows, and the way Jones evokes a sense of movement through a curve of repeated forms, echo Paul Klee's idea of taking a point for a walk. The positioning of amorphous shapes against a flat ground reflects his interest in the paintings of Kandinsky, particularly the *Improvisations* executed before the First World War. References to recent artistic developments are evident in the stripes of colour at top right, which recall Morris Louis's paintings, and in the heraldic shapes arching across the top half of the painting, which allude to the paintings of Kenneth Noland, Ellsworth Kelly and Josef Albers among others. Jones's treatment of space is similarly ambiguous, simultaneously conveying the illusion of openness and emphasising the flatness of the bare canvas. Such fusion of different art historical and stylistic references was one of the main characteristics of the Pop movement and would recur in Jones's subsequent work.

PM

Oil on canvas
182.9 × 182.9 (72 × 72)

Provenance
Purchased from Arthur Tooth & Sons Ltd, London, by E.J. Power Feb. 1962

Presented by E.J. Power through the Friends of the Tate Gallery 1980

JOHN HOYLAND born 1934
April 1961 1961

Oil on canvas 152.5 × 152.7 (60 × 60⅛)

Purchased from the artist through Waddington Galleries, London,
by E.J. Power after Dec. 1977
Presented by E.J. Power 1983

April 1961 belongs to a group of related paintings which Hoyland completed in 1961. The common theme of these works is an approach to composition in which horizontal lines of varying thicknesses, at varying distances apart, traverse the space of the canvas. In *April 1961* the width of the lines, and the spaces beween them, increase towards the centre of the painting. As a result, the lines at the mid-point of the canvas appear to advance and the space of the picture seems convex. This illusion is supported by the semblance of recession as the lines converge progressively towards the top and bottom of the painting. The impression of a curved pictorial space also arises from the way the lines are deflected near the left and right edges.

At the time he made this work, Hoyland was teaching at Hornsey College of Art. During this period he was actively involved, both as a teacher and as an artist, in debates which focused on issues of perception. Perceptual complexity also characterises the work of a number of other artists with whom Hoyland had exhibited, notably Bernard Cohen, Robin Denny and Peter Stroud. All had shown paintings in the *Situation* exhibition in 1960. Hoyland's concerns focused in particular on the problem of eliminating recognisable forms and working solely with abstract elements, while also retaining an implication of space and pictorial illusion. *April 1961* exemplifies his engagement with these ideas.

PM

JOHN PLUMB born 1927
Edgehill 1962

PVC, vinyl and cloth tapes over emulsion paint on canvas
181 × 121.9 (71¼ × 48)

Purchased from the artist by E.J. Power 1962
Presented by E.J. Power through the Friends of the Tate Gallery 1962

This work is of the type which Plumb showed in the Situation exhibition in 1960. Like some other *Situation* artists, Plumb was interested in urban modernity and industrial design. This manifested itself in his use of coloured plastic tapes, such as might be used for colour coding in electrical circuits, which he applied to the painted surfaces of his canvases. He first introduced tapes into his work in 1959 and over the next few years they became the dominant element of his compositions. In using these tapes Plumb was relying in part on readymade materials. However, his technique remained strongly improvisational and gestural. He would rapidly apply and strip off the tapes several times until he felt instinctively that he had arrived at the final composition.

Edgehill is one of a group of paintings in which Plumb used titles associated with either battles or legend. The battle of Edgehill, which took place in Warwickshire in October 1642, was the first major encounter between Royalist and Parliamentarian troops in the English Civil War.

MP

ROY LICHTENSTEIN born 1923
Wall Explosion II 1965

Enamel on steel 170.2 × 188 × 10.2 (67 × 74 × 4)
Purchased from Galerie Ileana Sonnabend, Paris, by E.J. Power
1965
Purchased from E.J. Power 1980

Wall Explosion II is a wall-mounted sculpture depicting an explosion in a style of illustrations in comics. The centre of the explosion is white surrounded by yellow. From this central area seven red and yellow bolts, bordered by black, strike outwards, passing through a red flash behind which is a grey mesh.

It is one of a small group of sculptures on the theme of explosions which derive from a painting of 1963 titled *Varoom* (Mr and Mrs John Powers, New York). Lichtenstein's source for this painting and the sculptures was an illustration in a D.C. Comic. These comics focused on the Second World War and were popular reading for boys in the 1960s. In *Wall Explosion II* Lichtenstein has simplified and decontextualised the original comic design. Like all of his work, this sculpture is ironic. The steel mesh, while suggesting cloud, is a play on Benday dots used in the printing process, although being a sculpture the work has no relation to that process. Indeed, in the original comic image the dots were barely visible. Furthermore, made at a time in which the USA was heavily involved in the Vietnam War, this sculpture anaesthetises violence, turning a destructive explosion into a simplified icon of beauty.

JL

TESS JARAY born 1937
Fifteen 1969

Oil on canvas 223.5 × 431.8 (88 × 170)
Purchased from the artist by E.J. Power 1973
Presented by E.J. Power through the Friends of the Tate Gallery
1973

Jaray has described this painting as the culmination of a series of highly structured paintings which she produced between 1967 and 1969. In these works she used paired geometric forms to create compositions which, although executed in pale and neutral colours, retained a sense of dynamism and 'tension (but not stress) held in equilibrium'. Jaray believed that the spectator in some way participated in the dynamics of the composition through the movement of the eye across the canvas. The separate elements were intended to draw the eye from one part of the composition to another, without allowing it to rest in any one place for too long.

Fifteen is one of only two paintings produced at this time in which the title is not associative or allusive but, rather, descriptive of the component parts of the composition. The artist envisaged the fifteen paired elements as 'perhaps a continuation of ying and yang, a male–female completeness, duality of night and day – all the elements of life which are unique in themselves yet absolute as a pair'. This reflected her desire that painting should be read as a microcosm of the universe, evoking a sense of underlying structure yet remaining at the same time 'mysterious' and 'ungraspable'.

MP

WILLIAM TURNBULL
born 1922

No.1 1962

Turnbull was one of a group of British abstract painters who in 1960 organised the *Situation* exhibition at the RBA Galleries in London. Works in the exhibition had to be large enough to enable the viewer to relate to them environmentally, and attention was drawn to the space extending outwards from their flat, non-illusionistic surfaces. *No.1* was painted just over a year after *Situation* and is consistent with these aims.

Turnbull was concerned with pure painting. He believed that a painting without external references could be no less sensuous and life-connected than representational art. He was also interested in intensity of colour. He wrote in 1960: 'I'd like to be able to make one saturated field of colour, so that you wouldn't feel you were short of all the others.' In painting, his interest in colour took precedence over that in shape. Wishing to be able to put different colours together in the same painting without creating shapes, he deliberately blurred their junctions. The result, as in *No.1*, was that the edges of blocks of colour not only distinguished one from another but also joined the blocks together. As Turnbull wrote in 1963: 'I am concerned with the canvas as a continuous field, where the edge created by the meeting of coloured areas is more the tension in a field than the boundary of a shape.'

In *No.1* the viewer's attention is drawn to the interplay between the work's division in terms of hue and its real physical division into two discrete canvases. The prominence accorded by the work's form to each of these features attests Turnbull's preference for an art that exposes the facts of its own making, undramatically yet with a clarity that is expressive in itself. He sees controlled manual activity as being as revealing of the artist, and as positive in terms of action, as are the modes of more rhetorical forms of art.

Turnbull's work as a painter has always shown keen awareness of the canvas's containing edge. Eschewing a concern with composition and allowing single colours to predominate within single canvases, Turnbull has over the years increasingly used relationships *between* canvases as the means of exploring those between colours. Each painting is seen, therefore, not only as a container of colour but also as a unit in itself. *No.1* consists of two canvases of identical size, butted together. Although this painting is radically different in appearance from Turnbull's multi-part, stacked sculptures of 1956–62, the two art forms manifest a common sensibility, for Turnbull felt that any discrete part of a work must be a self-sufficient entity. Thus, *No.1* invites consideration of the character of each of its component canvases as an image in itself.

By contrast with Turnbull's paintings of the late 1950s, *No.1* is thinly painted, but this entails no diminution in visual gratification. The painting exudes its own kind of energy, inherent in the relationship between its colour and the exposure of the physicality of its support. In 1961 Lawrence Alloway wrote of Turnbull's painting that his 'colour is flat and bodiless as a dye, so that the tangibility of the canvas surface itself is preserved. The luminosity of his colour thus appears to emanate from the surface; it does not … dissolve the surface'. As the same writer had observed no less perceptively the year before: 'His paint is washed thin and clear, so that the surface is a softly breathing skin, very painterly despite its simplicity. Thus Turnbull's simplicity is unlike the simplicity of linear and conceptual forms in early abstract art. It is nearer to Matisse than to geometric art.'

RM

Oil on two canvases
overall dimensions 254 × 375.9
(100 × 150)

Provenance
Purchased from the artist by E.J. Power 1962

Presented by E.J. Power through the Friends of the Tate Gallery 1962

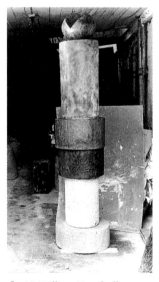

fig.12 William Turnbull, *Oedipus 3*, 1962, bronze, rosewood and stone 193.6 × 48.2 × 48.2 cm. Private Collection, London

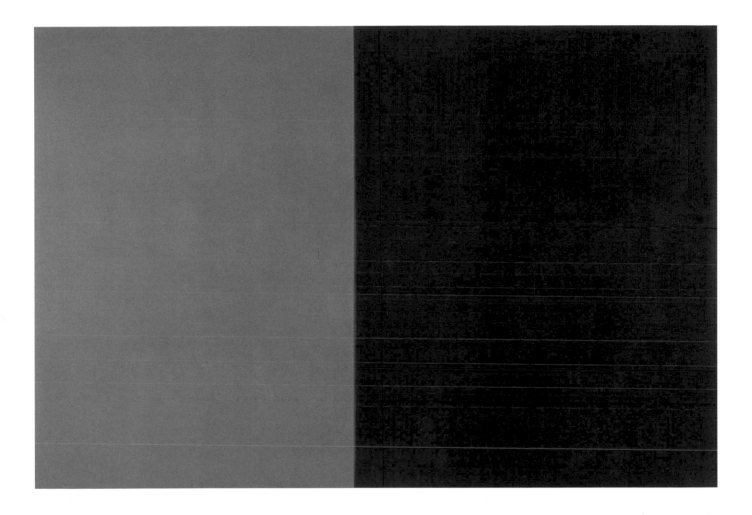

JOSEPH BEUYS
1921–1986

Fat Battery 1963
Fett Batterie

Fat Battery is one of two closely related works made by Beuys in 1963. The objects in the Tate Gallery's version of the sculpture resemble more obviously the shapes and functions of real batteries than those in the other *Fat Battery* (private collection). At one end of the box is a rectangular tin with rounded corners, paired with its lid. At the other end are two linked cylindrical casings, which are corroded by acid and were, possibly, part of a real battery. In each of these pairings of metal containers, energy is conducted between the dual chambers – respectively by a metal can-opener and by a felt 'lead'. The centre of the box is occupied by assemblages of felt and fat separated by a round metal disc. The Tate Gallery's work is housed in a robust, corrugated cardboard box of the type used to pack cans or jars. The other 'battery' is contained in a shallower box designed for storing paper. This version consists of an informal arrangement of felt pieces, some of which are layered and filled with fat.

The origination and transfer of energy was one of Beuys's central preoccupations. He conceived energy as the generative source for all manner of physical, mental or creative activities and selected a wide variety of materials to represent its catalysing or transformative powers. Among these materials are those which, like fat, can be sources of energy. Others, such as felt, insulate and retain warmth, and suggest ways energy can be stored.

Many of Beuys's works pose challenges to public museums and galleries, which typically attach a high premium to the longevity of the works they consider for acquisition. The fragility and instability in some of Beuys's sculptures embody the shifting, contingent ideas of flux and change that permeated his creative process. Providing a basic model for generating and distributing energies created by physical processes, *Fat Battery* epitomises these ideas. Formed with the poorest of materials and housed in its own micro-environment, it appears a modest variant of a grand apparatus.

Fat Battery holds a particular place in the history of the Tate Gallery's response to Beuys. Opportunities for acquisition increased in the early 1970s as his profile – and notoriety – grew through international exhibitions. In this period he was expelled from the staff of the Düsseldorf Academy and became involved in grass-roots democratic politics. In 1972 the Tate acquired a small bronze sculpture of 1950, entitled *Bed*, which was not typical of the more informally structured sculptures for which Beuys was then becoming widely known. Influential supporters in Britain urged further acquisitions. However, the Tate Gallery did not acquire *Fat Battery* when the work was first put forward for consideration in 1974. Ted Power, a Trustee at the time, secured its future in Britain by purchasing it for his own collection.

Fat Battery eventually entered the Tate Gallery's collection a decade later. In the summer of 1984 Beuys visited the Tate, bringing with him artist proofs of two newly cast sculptures. He offered to place these in a new 'vitrine', or glass-fronted display case, to accompany two vitrines by him that the Gallery had recently acquired. He proposed that also included in this new vitrine should be *Bed*, already in the collection. Discussions with Beuys and the Gallery led to Ted Power presenting *Fat Battery* to the Tate, with the expectation that it, too, would normally be displayed in this vitrine, as the fourth of the elements presented in a disposition determined by Beuys. Particularly in the latter part of his career Beuys used such vitrines to display thematically related groups of works from different periods.

SR

Felt, fat, tin, wood and cardboard
13.2 × 37.3 × 24.8 (5¼ × 14¾ × 9¾)

Provenance
Purchased from the artist by Wide White Space Gallery, Amsterdam, 1967; sold to E.J. Power 1974

Presented by E.J. Power through the Friends of the Tate Gallery 1984

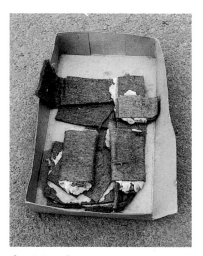

fig.13 Joseph Beuys, *Fat Battery*, 1963, mixed media 12 × 35 × 55 cm. Private Collection

54

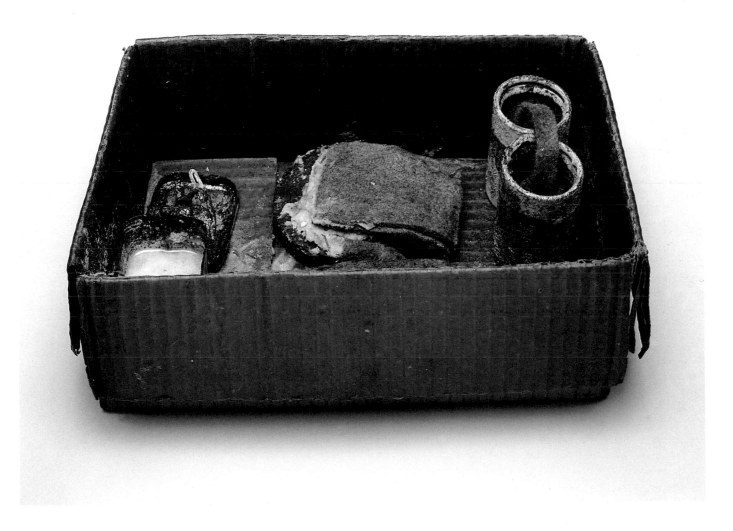

SIR HOWARD HODGKIN
born 1932

Mr and Mrs E. J. P. 1969–73

This is one of a series of four paintings of Ted and Rene Power, commissioned by Power from the artist. Its arrangement of textured but generalised hard-edged forms in clear, bright colours, where patterned surfaces are juxtaposed with flat, almost geometric, shapes is typical of Hodgkin's *intimiste* paintings of the period. The compact design evokes, rather than literally depicts, an interior with figures. *Mr and Mrs E. J. P.* is executed on a piece of plywood, possibly originally intended for domestic use. Hodgkin has often painted on wood panels, such as breadboards and table tops, and these emphasise the strong object quality of his paintings. The artist painted a frame-like border around the composition, a device he has often used.

The intensity of Hodgkin's vision, and the way he suggests space through the juxtaposition of differently textured passages, has often led critics to compare his work to that of the French painter Edouard Vuillard (1868–1940). In *Mr and Mrs E. J. P.* the freshness of the surface belies the work's slow gestation. While in recent years Hodgkin's brushmarks have become more apparent and his surfaces more illusionistic, in earlier paintings he used a less homogenous and more simplified language of blobs, stripes, and discs.

Hodgkin's paintings may be understood as narratives – accounts of certain elements or events that have touched the artist – mediated though imagination and memory and conveyed in a distilled painterly language. In 1966 Hodgkin described his works as being about 'one moment in time involving particular people in relation to one another and also to me'. A few years later he described his portraits as attempts to create an 'amalgam between the individuals and their surroundings as well as between one another'. His subjects have often been people closely connected with the world of art.

The artist has indicated that all four paintings of Ted and Rene Power, which were completed over a period of about four years, may be understood as representations of a conversation he had with Ted Power in the sitting room of Power's apartment in Grosvenor Square. In the early 1970s, when both were Trustees of the Tate, Hodgkin and Power would often go back to this apartment for a drink after board meetings. In a catalogue note for his exhibition *The Artist's Eye*, held at the National Gallery in 1979, Hodgkin described *Mr and Mrs E. J. P.* as, 'An interior containing two sculptures by Westerman, a Brancusi, a Pollock, a panelled wood ceiling etc. as well as the owners; the wife slipping away to the right and the husband talking in green in the foreground'. Hodgkin has also mentioned that the room always contained a sculpture by Giacometti and a Lichtenstein painting. He has referred to the green oval shape in the centre of his portrait of the Powers as representing the space occupied by Power while speaking.

The most closely related of the other works in the series is *Interior 9AG*, 1972 (Power himself suggested using the postcode for his Grosvenor Square flat in the work's title). Its composition is the reverse of *Mr and Mrs E. J. P.*, and it is a slightly larger work. The other related works are the much smaller *Family Portrait*, 1972, and *Interior Grosvenor Square* 1971–4.

CK

Oil on plywood
90.8 × 121.3 (35³/₄ × 47³/₄)

Provenance
Purchased from Arthur Tooth & Sons Ltd, London, by E.J. Power March 1974

Accepted by the Commissioners of Inland Revenue in lieu of tax and allocated 1996

fig.14 Howard Hodgkin, *Interior 9AG* 1972, oil on wood 109.2 × 139.4 cm. Mr and Mrs Ian McIntyre, Norfolk

BARRIE COOK born 1929
Painting 1970

Acrylic and charcoal on cotton duck 244 × 304 (96 × 119³/₄)

Purchased from the artist through Axiom Gallery, London, by E.J.
Power Oct. 1970
Presented by E.J. Power through the Friends of the Tate Gallery 1972

Painting is one of a series of eight or nine related works in which Cook's intention was to create 'a state of illusionism, based on a simple geometric device'. The image comprises a series of sprayed horizontal lines, arranged in parallel, whose course across the canvas space is inflected by a triangular device at the right-hand side. The lines appear to pass through this triangular form and, reading the painting from left to right, they are deflected upwards before resuming a horizontal arrangement. The resulting composition is ambiguous. In one way the image appears two dimensional: the lines are articulated within a flattened space. Alternatively, these forms can be read as if in relief, apparently advancing in front of the picture plane. This ambiguity, and the illusory nature of the image, are asserted further by Cook's treatment of the horizontal elements. The white lines, for example, can be read either as spaces separating dark masses, or as highlights on solid tubular forms whose edges recede into areas of dark shadow. Visual ambiguity is part of Cook's strategy to disorientate the viewer. The painting's large scale is intended to make this disorientation physical as well as perceptual. Cook was, he explained, 'making an attempt for people to see themselves as a whole, that is, a body and mind absolutely related to each other'.

PM

MARC VAUX born 1932
B/3L/73 1973

Acrylic on canvas 259.1 × 213.4 (102 × 84¹/₄)

Purchased from the artist by E.J. Power 1973
Presented by E.J. Power through the Friends of the Tate Gallery 1973

In the late 1960s and early 1970s Vaux made large-scale colour field paintings in which a small multi-coloured rectangle was situated in a much larger area of saturated colour. As with his earlier *Situation* works, Vaux believed that the large size of these canvases established them as real objects that shared the same space as the viewer, rather than as illusory representations of the world around us. He was keen to avoid any sense of traditional composition or spatial illusion, and found that this was best achieved by locating the small coloured rectangle near one of the edges of the canvas. He felt this minimised its importance and allowed him to emphasise his primary concern with the viewer by 'bringing about problems of how one positions oneself in relation to the whole painting'. The small scale of the coloured element was also intended to make the viewer move close to the surface of the canvas, reflecting Vaux's belief that a degree of physical participation was necessary for the painting to be viewed successfully. The title of this painting is a formula based on its component parts, where 'B' stands for the brown field of colour, '3L' refers to the three colours situated on the left of the painting and '73' is the year of completion.

MP

58

JOHN SALT born 1937
Pink Trailer 1977

Colour lithograph 43.2 × 64.1 (17 × 25¼) on J. Barcham Green
HP waterleaf paper 58.5 × 80 (23 × 31½); printed by Ian Lawson
and published by Anderson O'Day in an edition of 65

Donated by Anderson O'Day to AIR & SPACE Appeal Fund
Contemporary Art Auction, London, at which purchased by E.J.
Power 15 Oct. 1980
Presented by E.J. Power 1980

Although British, John Salt lived in America between 1967
and 1978. It was there that he began painting in a Photorealist
style, taking as his subject matter the wrecks of abandoned
cars and scenes of near-derelict trailers or mobile homes.
Although Salt maintained that he was not interested in mak-
ing a statement about contemporary life in America, it is dif-
ficult not to read these images as a wry comment on the
seamier sides of consumer culture. This particular pink trailer
appeared in a number of related paintings which Salt made
between 1974 and 1977. He used the same technique
whether working in oil, watercolour or the printed medium.
Using slide photographs which he had taken himself, he
would project the image directly onto the canvas or paper and
make a drawing of the outlines. He would then paint the
scene, using an air brush and sometimes stencils for certain
details such as the foliage.

MP

JOHN LOKER born 1938
Shifts (Gate) 1978

Etching and aquatint 46 × 39 (18 × 15⅜) on R.K. Burt 140 wove
paper 76.5 × 57 (30 × 22½); printed by Richard Michell at Print
Workshop and published by the artist in an edition of 50

Donated by the artist to AIR & SPACE Appeal Fund Contemporary
Art Auction, London, at which purchased by E.J. Power 15 Oct.
1980
Presented by E.J. Power 1980

This print relates to a series of paintings titled *Shifts* which
Loker made between c.1974 and 1979. In these works he
developed his interest in examining the perceptual experience
of landscape, using multiple or shifting viewpoints. Each *Shifts*
picture was divided into four horizontal sections. In the top
section Loker would paint a portion of landscape or, rather, a
response from memory equivalent to his experience of a
landscape. The marks which formed the scene were then
translated into the lower parts of the picture, using a shifting
viewpoint. Thus, when viewed from top to bottom, the image
is intended to read as though one were walking backwards
through the landscape, with the horizon gradually opening
up and new areas appearing in the foreground. In this print
the gate, which is the focus of the scene, can only be partly
glimpsed in the top section, before coming into full view in
the two central areas and finally receding into the distance at
the bottom of the image.

MP

PATRICK CAULFIELD
born 1936

Interior with a Picture 1985–6

Interior with a Picture is painted in an intense range of dark reds, oranges, yellows and browns, characteristic of Caulfield's paintings since the early 1980s. The composition includes an outlined banister, dado rail, and a decorative oval shape, as well as an area of elaborately patterned wallpaper. The artist copied the wallpaper design from a remnant he had found, building up the texture to resemble the flock paper sometimes used in restaurants. The oval shape was made by squeezing acrylic paint directly out of the tube onto the canvas.

The painting features a picture-within-a-picture, a device much favoured by the artist. In this instance, Caulfield copied an illustration in *Still Life Painting from Antiquity to the Present Time* by Charles Sterling, a book still in his possession. The illustration was of *Meal by Candlelight* (fig.15) by a German painter named Gottfried von Wedig (1583–1641). This panel painting represents a table top with flagon, salt cellar, burning candle, glass of wine and a wooden trencher bearing an egg in an egg cup, a knife and narrow strips of bread. The arrangement of objects suggests that the work could be a *vanitas*, an allegory concerning the transience of human existence, or perhaps an allusion to the Christian Eucharist. However, Caulfield chose to copy this work because, like many of his paintings of the time, it was concerned with the effects of an artificial light source on the objects and spaces around it. He was also interested in the unusual and seemingly rather modern look of the image.

Caulfield does not use mechanical methods for enlarging images. His representation of the von Wedig work necessitated his squaring up the book illustration using pieces of cotton thread so as not to spoil the illustration. His version is approximately the same size as the original painting, although the book illustration he used was smaller. Caulfield attempted to make his copy of the work as accurate as possible, despite having to transcribe an image originally made on wood onto the more uneven texture of canvas. He painted a simple, modern frame around the still-life image, and illuminated the work by a shaft of yellow light which issues from a concealed source. A concern with the play of light on surfaces is a theme common to both the von Wedig picture, Caulfield's representation of it, and to the composition as a whole. Caulfield chose to call this work *Interior with a Picture* because his is only a version of a photograph, or *picture* of von Wedig's original painting.

CK

Acrylic on canvas
205.7 × 243.9 (81 × 96)

Provenance
Purchased from Waddington Galleries, London, by whom sold to E.J. Power March 1986

Accepted by the Commissioners of Inland Revenue in lieu of tax and allocated 1996

fig.15 Gottfried von Wedig, *Meal by Candlelight*, oil on wood 34.5 × 27 cm Hessisches Landesmuseum, Darmstadt

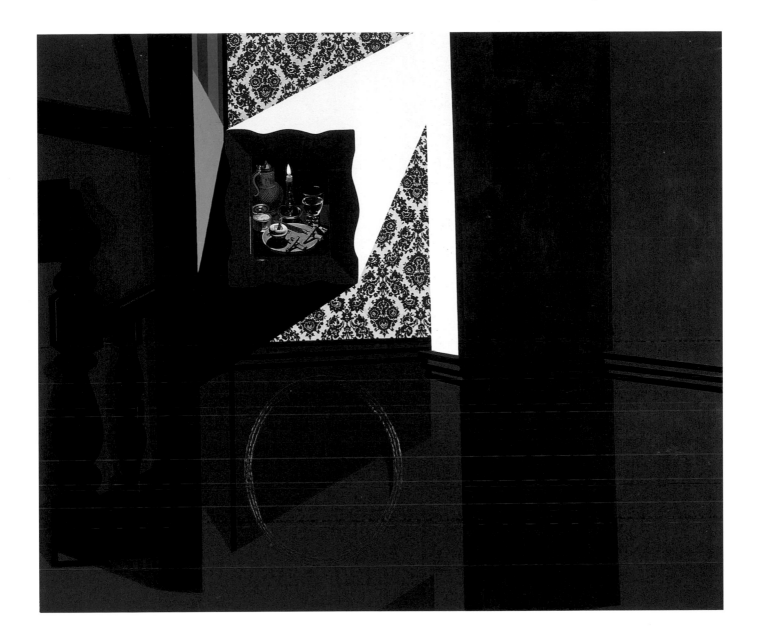

SIR HOWARD HODGKIN born 1932

Early Evening in the Museum of Modern Art
1979

Soft-ground etching with hand-colouring in black gouache on grey BFK Rives mould-made paper 75 × 98.4 (29½ × 38¾); printed by Ken Farley and published by Petersburg Press, New York, in an edition of 100

Presented by E.J. Power through the Friends of the Tate Gallery 1980

Thinking Aloud in the Museum of Modern Art
1979

Soft-ground etching on Hodgkinson hand-made paper 75.5 × 100.3 (29¾ × 39½); printed by Ken Farley and published by the Petersburg Press, New York, in an edition of 100

Presented by E.J. Power through the Friends of the Tate Gallery 1980

These are the second and fourth images of a set of four soft-ground etchings entitled *In the Museum of Modern Art*. The etchings were made in pairs, so that two plates were used to create four images. In each pair one print had additional hand-colouring, the effect of which was subtly to alter the mood of the composition. *Early Evening ...* is the hand-coloured version of *Late Afternoon in the Museum of Modern Art*, while *Thinking Aloud ...* was reworked with black gouache to become *All Alone in the Museum of Modern Art*.

These were some of the first prints by Hodgkin to match the scale of his paintings. They employ a range of dabbed and brushed marks, while the added hand-colouring enhances the illusion of changing light and deepening shadows. The etchings, which suggest airy space and views through windows, were inspired by visits to the Philip Johnson wing of the Museum of Modern Art, New York. The artist thought the Johnson rooms beautiful and was particularly struck by the large windows reaching down to the floor. Hodgkin has said that he was unhappy at the time, and this is perhaps reflected in the elegiac mood of these works.

CK

JOHN DUGGER born 1948
Sports Banner 1980

Six industrially dyed cotton canvas strips with appliqué, oil fabric paint and nylon rope supported on aluminium rod, each approx. 118.5 × 28.5 (46½ × 11¼); overall dimensions including rod but not ropes 122 × 200.5 (48 × 79)

Donated by the artist to AIR & SPACE Appeal Fund Contemporary Art Auction, London, at which purchased by E.J. Power 15 Oct. 1980
Presented by E.J. Power 1980

John Dugger began to make large-scale banners as public art in 1974. Some of his subjects were politically motivated, but he also made banners for commercial venues, theatres and other public arenas such as sports centres. Exhibiting a group of his sports banners at the Institute of Contemporary Arts, London, in 1980, he described the medium as 'a portable mural-without-walls'. It was his intention to make a form of public art in which there was a return to the original social function of art, in which 'artistic form and content ... serves the needs of the people in action'. His working methods and studio practice also reflected this notion of a return to traditional practice. In 1976 he established the Banner Arts Workshop where, working with a team of assistants, he manufactured banners from his original blueprints. Dugger's sports banners have featured motifs from judo, basketball and the Chinese martial arts, as well as images drawn from the field of gymnastics.

MP

INDEX OF CATALOGUED WORKS

Works shown in the exhibition are indicated by an asterisk